When will the book be done?

Granary's books

D1451392

When will the book be done?

Edited by Steven Clay Preface by Charles Bernstein

Granary's books

New York City 2001

For more information:

Visit our website at http://www.granarybooks.com to see more images from the books, sample chapters, introductions and, occasionally, complete works. Additionally, the website contains a database of out-of-print titles in the fields of artists' books, poetry, little magazines and art. We also deal in literary manuscripts and archives of the last thirty years. Your inquiries are welcome.

How to order:

The small edition books described in this catalog are sold through our New York office. Please e-mail or phone to place an order. The trade editions are available at your local bookstore, through our distributors (D.A.P. 1-800-338-BOOK and Small Press Distribution 1-800-869-7553) and direct from our office.

Project submissions:

Granary's books are always, or nearly always, commissioned; we are not able to consider unsolicited projects.

Granary Books, Inc.

307 Seventh Avenue, Suite 1401

New York, NY 10001

Tel: (212) 337-9979

www.granarybooks.com

orders@granarybooks.com

Distributed to the trade by

D.A.P. / Distributed Art Publishers

155 Avenue of the Americas,

Second Floor

New York, NY 10013-1507

Tel: (212) 627-1999

Fax: (212) 627-9484

Orders: (800) 338-BOOK

Library of Congress Cataloging-in-Publication Data

When will the book be done? / edited by Steven Clay; preface by Charles Bernstein.

p. cm.

Includes index

ISBN 1-887123-43-1 (pbk.: alk. paper)

1. Granary Books (Firm)

2. Artist's books-- United States.

I. Clay, Steven, 1951-

Z473.G73 W48 2000

070.5'0973--dc21

00-062276

Book design by Taller de Comunicación Gráfica

Cover illustration © Henrik Drescher

Contents

Claymation, a Reader's Guide

Charles Bernstein

Illustration George Schneeman & Anne Waldman from *Homage to Allen G.*

In something more than ten years—let's call it a baker's decade—Granary Books has produced about 100 books. Throughout the 1990s, Granary made itself home base for a group of bookmakers, poets and visual artists, brought together to make pages while the sun shines—and by moonlight (and halogen light, too).

At Granary, books are not neutral containers but are invested with a life of their own, conceived as objects first and foremost, entering the world not as the discardable shell of some other story but piping their own tunes on their own instruments. Nothing is taken for granted—the binder is as much a star as the printer or writer. The design is an extension of (not secondary to) the content, just as the content is an extension of the design. For a book, a Granary book, is never about delivering information in the most expeditious form. Piping down the valleys of bibliophilic excess has led to the palace of Clay—Steve Clay, Proprietor and Impresario Extraordinaire.

For one thing (but who's counting?) that means these works are collective productions. Of course, almost all books are collaborative, but in the typical case the lines of authority and creativity are delineated so that the collaborative element becomes fairly routine. Not so at Granary. As Mr. Clay notes in his introduction, Granary books are often initiated by his prompting and come into being as part of a process in which the bookmaking sets the stage for the book. In other words, most of the 100 or so Granary books did not exist as works before being conjured by Mr. Clay. There are notable exceptions, and certainly parts of many of the books have existed independently, but even in these cases the bookmaking process transforms the parts into something other than, something beyond, what was there before. More typically, the collaborators respond to one another's art to produce something that exceeds what any of them would have imagined alone.

At the heart of Granary Books is a series of artists' books, with special emphasis on works by book artists and poets and collaborations between poets and visual artists. The large majority of Granary books fit this category. But Granary has also produced a set of essential scholarly texts about the field of activity of which Granary is a leading exponent. Mr. Clay's on-going commitment to publishing a comprehensive set of critical writings about the book, each with a startlingly wide historical, philosophical and aesthetic scope, makes Granary unique among artist's book and poetry publishers. Taking formal self-reflection about books as a fundamental part of its project, Granary has arrived at a richly dialectical form of publishing.

Moreover, Granary's production is not only dialectical but also multiform. While many of the books are priced as limited edition works of art, others are priced (and printed) in a range typical of trade and scholarly publishing. The multiple types of books Granary publishes reflect the multiple realities for books at this particular moment in time. The book is not a singular category; each type of book has its potential but also its limit. With Granary, it's the interplay among the types that begins to tell the book's own story.

I have heard, among some of my poet friends, a certain skittishness about publishing books with small print runs and high costs. For many of us involved with poetry, the point is to get the work around in a way that creates the minimum barrier to distribution. Indeed, the free exchange of books remains a primary means of circulation. But perhaps this approach oversells the text at the same time as it undervalues the book. We need some books that are inexpensive and easily available, no doubt. But other books do well to explore alternatives to the standard formats of mass reproduction—to slow things down, to savor the ink, the binding, the paper; to put the art of the book back into the book. To make books as materially and aesthetically and visually rich as a painting or sculpture. Art

works such as these not only bring out the magic of books but also return us to the history of books. And perhaps it makes historical sense that Granary's reassertion of the physicality of the book comes just as so many of us are doing more and more reading on screens.

Granary Books insists—in words and deeds—that the currently dominant book formats, including the conventions of standard typography, layout and page dimension, may restrict meaning as much as facilitate its transmission. One copy of something different may be worth 1000 copies of the same.

The cover of a book is like the face of a person—and who can resist judging based on what is first encountered? But a cover is, after all, a lid—it hides what's inside. In this catalog one gets to sample the covers as well as the insides of the corpus of Granary Books. A sample, of course, may give you a taste for more. But, curiously, this particular book, this book of books, provides something that no one of the works depicted possibly can. For the images and texts that follow make a picture not just of discrete works but also of something that cannot be contained by a book, a publisher: a publisher's aesthetic, a publisher's production. One hand marks all of this: this plenitude of wondrous objects has a source.

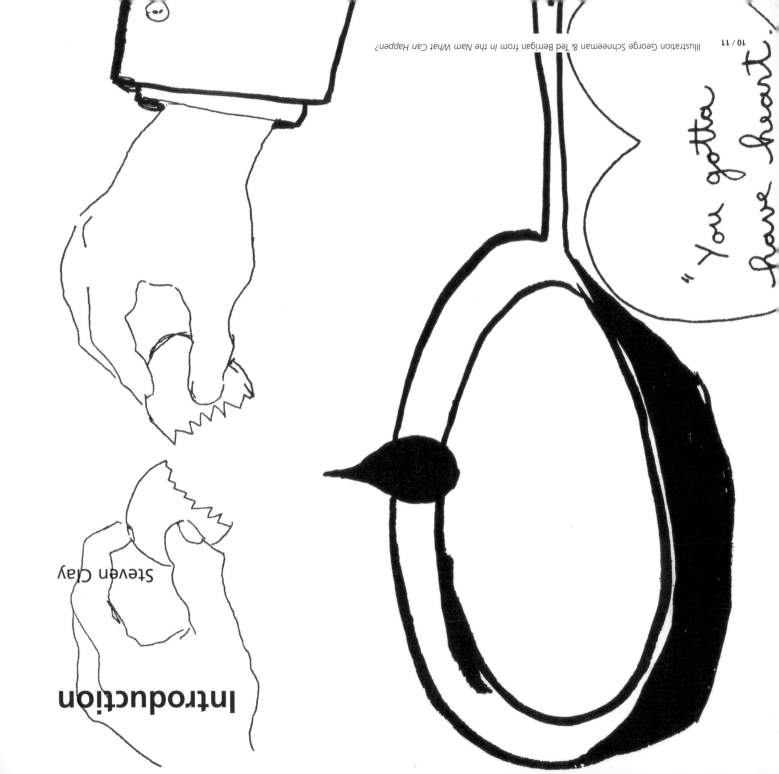

"You gotta have heart."

Illustration George Schneeman & Ted Berrigan from *In the Nam What Can Happen?*

Introduction

Steven Clay

The first item that I identify as a Granary Books' publication was actually published by Origin Books[2] in 1986—*Wee Lorine Niedecker* by Jonathan Williams. It embodies several elements that remain important to me now, some fifteen years later, among which is an acute awareness of the "book" as a physical object. I write this in quotes because the work in question is not a book *per se* but presents a short poem by Mr. Williams, printed on a small piece of card stock contained within a printed envelope which is enclosed within yet another printed envelope. As such, its references include Williams's own Jargon Society[3] ("the custodian of snowflakes"), a press which made ample use of a diverse array of publishing formats including folding cards, broadsides, postcards, pamphlets and books. The Jargon Society was one of two or three publishers[4] which loomed behind the emerald curtain at the fore edge of my imagination as possible exemplars for an entity which had not yet been conceived.

Publishing did not prove central to my concerns[5] until the advent of *Nods* in 1991. A sense of necessity was at the root of this project. There was a strong desire to connect with John Cage, whose music and writings (linking Buddhist philosophy with expansive yet centered notions and definitions of art and musical composition) had been crucial for me over the years (yet such influence is probably not evident to an outside observer). Although *Nods* fits easily among the group of artist/writer books published later, its seminal position marks, as much as anything, a way of collaborating, a procedural approach to working together with those involved in a particular project. *Nods* brought together the writings of John Cage and the drawings of Barbara Fahrner.[6] Mr. Cage gave Ms. Fahrner permission to perform chance operations on his published works toward arriving at a new text; she then made a series of drawings after the book had been set in type by Philip

1
The first work published by Granary was a broadside, an ominous beginning as it presented a horribly depressing vision of books and the book trade by John Locke (with which I only partly agree).

2
Origin Books was a poetry bookshop run for a couple of years by Merce Dostale and myself in Minneapolis. The shop was named after Cid Corman's magazine. I remember one particularly germinal afternoon being visited by Alison Circle, then of Black Mesa Press (a precursor to present-day Chax Press)—Ms. Circle asked, "If you could publish anybody you wanted, who would it be?" I immediately answered, without thinking, "Jane Brakhage." [Now Jane Wodening.] I'd read Jane's odd, eccentric and almost experimental stories in the "Lump Gulch Tales" column of Ed Dorn's and Jennifer Dunbar Dorn's magazine *Rolling Stock*. I later met Jane in New York during her camouflage-road-garb and matted-hair period—a fascinating and intimidating sight. I screwed up my courage and invited her out for a muffin the next morning. Granary published her first book, *From the Book of Legends*, in 1989.

3
The Jargon Society, founded in 1951 (the year I was born), was an education in both publishing/bookmaking and literature, particularly the first twenty years. Weaned by Sherman Paul on Olson, Duncan and Creeley, the Origin/Jargon nexus occupied a royal spot in my imagination. Holding a copy of *Origin* II featuring Robert Creeley, for example, or *Maximus 1-10* by Charles Olson—these were expansive moments. Jargon not only published terrific writing by the likes of Zukofsky, Levertov, Williams, Niedecker, Loy, Oppenheimer, Dawson...they did so with a defining sense of style, care and commitment.

Gallo[7] at The Hermetic Press. Subsequently, the edition was bound by Daniel Kelm[8] at the Wide Awake Garage. What came together in my mind quite vividly as this project concluded, were the (until then) seemingly disparate elements of publishing: words, pictures, printing, binding and distribution. In a very real sense, Granary as a publisher was born with *Nods*; this book was the foundation of the master plan without a master plan, very much in keeping with my sense of Mr. Cage's logic.

It is convenient for me to observe now what was neither clear nor evident at any other point during the last fifteen years. Looking back, I see the publishing activity of Granary Books falling into three broad and overlapping zones of activity: 1) artists' books[9] 2) books of theory and documentation pertaining primarily to books, writing and publishing[10] and 3) writer/artist collaborations.[11]

The daily reality of the process of publishing was that one book led to the next and the next and the next (nearly 100 times now), with no predetermined plan of who or how to publish,[12] with hardly any sense of how to pay for it all[13] and equally little sense of how to distribute the works once produced.[14]

Although the impulse to publish was imbued with (or defined by) a sense of writing and poetry, most of the dozen books immediately following *Nods* were primarily visual, created as if to make evident, in a very literal sense, what Stephane Mallarmé meant when he wrote that everything in the world exists in order to end up as a book. The series of projects which followed were caught up in, among other things, their own material, visual and sensual inclusiveness; the ideas driving the work demanded, and to some

4
Dick Higgins's Something Else Press (founded in 1964) ranks high as well. Associated with Fluxus, Something Else produced books remarkable for both form and content. The designs had a fascinating new/old look; the exotic content lured me far away from my Midwestern roots. Another important exemplar was Coracle Press (founded in 1975), then of London, now of Tipperary in Ireland. Coracle produced (and produces) a wide range of materials: poetry, criticism, essays, artists' books, postcards, catalogs—with a particular reverence for the small scale. Simon Cutts (now in partnership with Erica Van Horn) and Coracle have decisively extended and grounded my sense of publishing.

5
From the mid-1980s to the mid-1990s, primarily at Granary's gallery space in Soho, we curated (with much help from others) and hosted innumerable exhibitions, lectures, performances, musical events, poetry readings and publication parties.

6
Barbara Fahrner is a German artist whom I first encountered at the Frankfurt Book Fair in 1989. She'd recently completed "Das Kunstkammerprojekt," a work of massive intellect and imagination.

7
Philip Gallo studied with Harry Duncan in the mid-1960s. His Hermetic Press has issued a veritable trickle of found and concrete poetry (all by Mr. Gallo) since about 1970. For years (and to his obvious delight) the reach of Mr. Gallo's audience extended for about one block around a bar at the corner of Lake and Hennepin in Minneapolis. It has since reached beyond that somewhat.

In the early 1990s there was a dearth of information[16] which might establish a useful overview of recent activity, relevant historical precedents and a set of critical terms for framing and talking about artists' books. Discussions with Johanna Drucker revolved around the idea of a traveling exhibition and an accompanying descriptive catalog. Tony Zwicker and I spoke about editing a new volume of writings modeled on Joan Lyons's work, *Artists' Books*. For specific reasons now forgotten, the exhibition and the anthology didn't happen. The whole project was conflated into Ms. Drucker's seminal study, *The Century of Artists' Books*,[17] which Granary published in 1995. I decided upon a first printing of

extent were determined by, an extravagant edifice. A massive range of materials and techniques were exploited (letterpress, offset, etching, photo-transfer, drawing, painting, tearing, collage, metal, latex, fur, wax, rubber and sandpaper to name but a few) in the service of realizing artists' books[15] by Shelagh Keeley, Pati Scobey, Tennessee Rice Dixon, Toni Dove, Jane Sherry, Timothy Ely/Terence McKenna, Buzz Spector, Carolee Schneemann and Holton Rower, among others. My motivation for producing such works was counter to what I perceived was then happening in "book arts," where on some level, the crafts of bookbinding, printing and papermaking often appeared to be the driving force behind the finished work. I imagined these Granary publications to be anthropological as much as aesthetic artifacts, where craft *per se* was seen as a technology, a means of getting things done, rather than as an end in and of itself. The desire was, in part, to resonate or rhyme with books from cultures and times very different from our own and to seek out a form of visual language rooted in the acts of assembling and marking, i.e. handwork. Toward that opening, the encouragement of scholarship and documentation of the work began to take on additional significance.

8
I first encountered Daniel Kelm's work at a birthday party for Tim Ely* in 1989 near Northampton, MA. He showed and described a recent work called *The Earth Book* made in an edition of three—which was very much under the influence of studies in alchemy and bookbinding—a rich mixture of chemistry, poetry, craft and intelligence. Mr. Kelm aptly likened the role of publisher to that of midwife.
*Timothy Ely's work was presented in a slide lecture given by Ruth and Marvin Sackner at Granary's office in Minneapolis around 1986. There were perhaps six people in the audience. When the work of Mr. Ely appeared on the screen, the floor moved palpably.

9
As Stefan Klima has pointed out, "definition" has been the dominant topic of published discourse around artists' books since the early 1970s. At the risk of flogging a dead horse, let me quickly interject that in my estimation, artists' books are best understood within a wide context nurtured by several lineages and as such they show up, in our time, in a vast array of proliferating forms, quickly changing guises as soon as any one definition seems certain.

10
This list extends to include occasional books about music and film.

11
In regard to the controversial *livre d'artiste* I quote David Antin from his essay "The Stranger at the Door": "The viability of a genre like the viability of a family is based on survival, and the indispensible property of a surviving family is a continuing ability to take in new members who bring fresh genetic material into the old reservoir. So the viability of a genre may depend fairly heavily on an avant-garde activity that has often been seen as threatening its very existence, but is more accurately seen as opening its present to its past and future."

4000 copies in hardback, and later learned that this was perhaps a somewhat large first run for a scholarly book. Nevertheless, 3000 copies in paper were printed in 1997 when stock in cloth dwindled to about a thousand. The lion's share of the sales have been generated by word of mouth—there have been only a handful of reviews and those were published primarily in off-the-screen journals. *Century* was (and is) distributed, as are all of our trade books, by D.A.P. (Distributed Art Publishers),[18] thus beginning our continuing association.

Emboldened by the success of *Century*,[19] we brought out *The Book, Spiritual Instrument*,[20] edited by Jerome Rothenberg and David Guss in 1996. This is a lean and learned work which focuses on relations between ancient and modern forms of the book and writing, "…a vision of books as laboratories for the invention and performance of perceptual systems: new worlds carved out of the wilderness of human thought and language."[21] Discussions with Mr. Rothenberg inevitably led to another book, further exploring the regions hinted at in *The Book, Spiritual Instrument*. After a couple of years of editorial work, Granary published our co-edited *A Book of the Book: Some Works & Projections about the Book & Writing*. These books join a growing shelf of Granary works devoted to the study and documentation of books, writing and independent publishing, including Stefan Klima's *Artists Books: A Critical Survey of the Literature*, Judd D. and Renée Riese Hubert's *The Cutting Edge of Reading: Artists' Books*, Steven Clay's and Rodney Phillips's *A Secret Location on the Lower East Side: Adventures in Writing, 1960-1980: A Sourcebook of Information*, Aaron Fischer's *Ted Berrigan: An Annotated Checklist*, Johanna Drucker's *The Century of Artists' Books* and *Figuring the Word: Essays on Books, Writing and Visual Poetics* and Anne Waldman's and Lewis Warsh's *Angel Hair*

12
The works published are nearly always initiated by Granary; seldom, if ever, do they come in over the transom. I would suggest that this is typical of an independent press and almost unheard of among mainstream publishers.

13
The cost of producing small edition works is anywhere between 10K and 30K out-of-pocket expenditures. The major trade books cost between 25K and 40K while the trade poetry books cost between 2K and 4K, depending primarily on the nature of the cover.

14
But what does it mean to distribute a work that exists in an edition of perhaps thirty copies for sale? In David Antin's words, "What is the radius of the discourse?" Is the radius significantly increased as the price goes down? As the edition size goes up? One wants to say yes, yes it is increased—but for most of the works described in this catalog (and for art works in general) I'm not so sure. The radius of discourse for a painting by Jackson Pollock, for example, is quite large in spite of its existence as a unique object and its astronomical price (if for sale at all). Johanna Drucker identifies the crucial element as being content, and I tend to agree.

15
Two statements by Robert Creeley seem to have been imprinted onto my consciousness and have consequently played themselves out in all of Granary's books: a) "form is never more than the extension of content" (which came to me by way of an essay by Olson) and b) "never write/to say more/than saying/something" (from *Pieces*).

Sleeps with a Boy in My Head: The Angel Hair Anthology. As of this writing, I am collaborating with David Platzker to publish a book documenting the twenty-five-year history of Printed Matter Bookstore.[22] We also have plans to publish a catalog documenting the archive of dealer and collector Tony Zwicker.[23]

Finally, the primacy of words and writing to the Granary publications again becomes more evident in the mid-1990s with books conceived of as collaborations between poets and artists exploring and identifying verbal/visual relations, possibilities and limitations. This is a particularly rich vein of activity to mine because the tradition of the poet/painter book is highly referential and has a long and sometimes tawdry past. Yet within this rather traditional mode of working lie the possibilities for being blind-sided by the new and the unexpected. Recent collaborations include works by Kimberly Lyons and Ed Epping, Joe Elliot and Julie Harrison, Lyn Hejinian and Emilie Clark, Jerome Rothenberg and David Rathman, Charles Bernstein and Susan Bee, Ted Berrigan and George Schneeman, Robert Creeley and Elsa Dorfman, Clark Coolidge and Keith Waldrop, Anne Waldman and Susan Rothenberg, Larry Fagin and Trevor Winkfield, among many others. As always, we aim at a means of production appropriate to the work at hand, with a determination to incite and expose multiple senses of how and what a book might be.

One of my very first lessons in business was to understand that most work is accomplished in cooperation with other people. It is thus one of my great and enduring pleasures to have had the opportunity to work with the people identified throughout this catalog and to count a great many friends among them. This book is dedicated to them all. Furthermore I wish to acknowledge and thank several people whose efforts specific to

16
I have a three-foot shelf of materials pertaining to artists' books in my library. In 1990 I sorted out the useful titles and it quickly boiled down to a handful of catalogs and one book: *Artists' Books: An Anthology and Sourcebook* edited by Joan Lyons, first published in 1985. *Artists' Books* charts a significant range of work and, much to its credit, is not driven by ideology. However, for a genre growing as rapidly as artists' books at that time, something new and relevant was an urgent concern.

17
In 1995, MOMA's exhibition, *A Century of Artists' Books*, and its accompanying catalog by Riva Castleman, seemed off the mark. Ms. Drucker's use of the word "the" in her title, rather than "a," was a challenge to the somewhat narrow interpretation comprising the MOMA exhibit.

18
Our trade books, and some of the small editions, are also available from the premier source for new poetry and poets in this country, Small Press Distribution, of Berkeley, CA.

19
Success is measured here not in dollars but in number of copies sold. My best inside sources confide that, in scholarly publishing, success equals 2000 copies sold. In dollars, given the $35,000 initial investment, after five years we've just about broken even.

20
Having followed Jerome Rothenberg's work for twenty years, including the several magazines he edited, I say with some degree of embarrassment that I had never laid eyes on issue #11 of *The New Wilderness Letter* subtitled "The Book, Spiritual Instrument." As I was poking through books one winter's

this catalog are amply evident. Estela Robles, designer extraordinaire, graced our offices with her impeccable skills for several months during the summer of 2000 on an extended visit from Mexico City. Gratitude to Emily Y. Ho for her irrepressible bibliographical proclivities, to Amber Phillips for her well tempered organizational choreography, to wordslingers Charles Bernstein and Johanna Drucker for their rare abilities to articulate the ineffable and to our indefatigable summer intern, Daniele Anastasion. Grateful thanks to special friends Michael Mann and Deborah Wexler, who have been of crucial importance to the project of Granary over the years, in ways immeasurable. And finally, but essentially, to my partner Julie Harrison—thanks for the fount of aesthetic, editorial and moral input germane to the realization of this and so many other Granary books—loving affection to her.

morning at Carolee Schneemann's house, there it was. A half-dozen attempts over the next couple of months to locate additional copies turned up nothing. Thus, the reprint.

21 Quoted from Charles Bernstein's cover blurb.

22 Since 1976, Printed Matter, located in New York City, has served as a tremendous resource for artists' books, complimenting its distribution activities with exhibitions and publications.

23 Tony Zwicker was the spiritual godmother of a great many artists whose paths in and through books she dignified with her rare intelligence and generosity.

Plates and Citations

The following pages provide details about Granary's publications from 1985-2001. Each entry includes bibliographical information with additional notes, critical and anecdotal material gleaned from various reviews, prospectuses and statements by the writers and artists themselves.

Dimensions are in inches, height by width. Books are generally organized by author's last name.

"*The Review of Contemporary Fiction* was preparing an issue on my work and they wanted to include a new interview to go along with six or seven critical essays. Over the years I'd been interviewed a fair number of times by some very able critics, but I thought it might be interesting to try something different. Not so much an interview as a conversation—with another poet, a younger poet whose mind and work I found powerfully meaningful. I immediately thought of Charles, his wide-ranging mind, his openness to all sorts of genres and modes, his quickness, his lightness, his seriousness....And there were obvious similarities in our interests and backgrounds. We're both dedicated experimentalists, both poet-critics, both New York and secular Jewish. But there were great differences. We started from two different worlds. I was born into the Great Depression and he was born into the Cold War eighteen years later. I came into the art and literary worlds of the late fifties, he entered in the seventies. We would have a lot to talk about, and we talked about doing it. I went East for an opening at the Whitney. Charles came out to San Diego to read a paper. Since I'm a 'talk poet' and Charles a voluble talker, we thought we should do it face to face for audiotape. But since I live on the West Coast and he lives on the East Coast, this was difficult to arrange. At a conference on American poetry in Amiens we decided we might as well do it by e-mail, which offers some of the immediacy of talking together with the elaboration possibilities of writing. The electronic speed of transmission made it a kind of cross between the 18th century and the 21st. The elaboration process led us to a four month interchange we enjoyed so much it ran more than twice the length we could use in *The Review of Contemporary Fiction.* This book is our whole uncut dialogue."

David Antin

Photograph (opposite) of David Antin by Phil Steinmetz. Offset. Bound in paper wrappers. Twenty-six copies are signed by David Antin and Charles Bernstein.

ca. 100 pages

ca. 9½" x 6" ca. 2000

2001 Edition of

David Antin & Charles Bernstein

A Conversation with David Antin

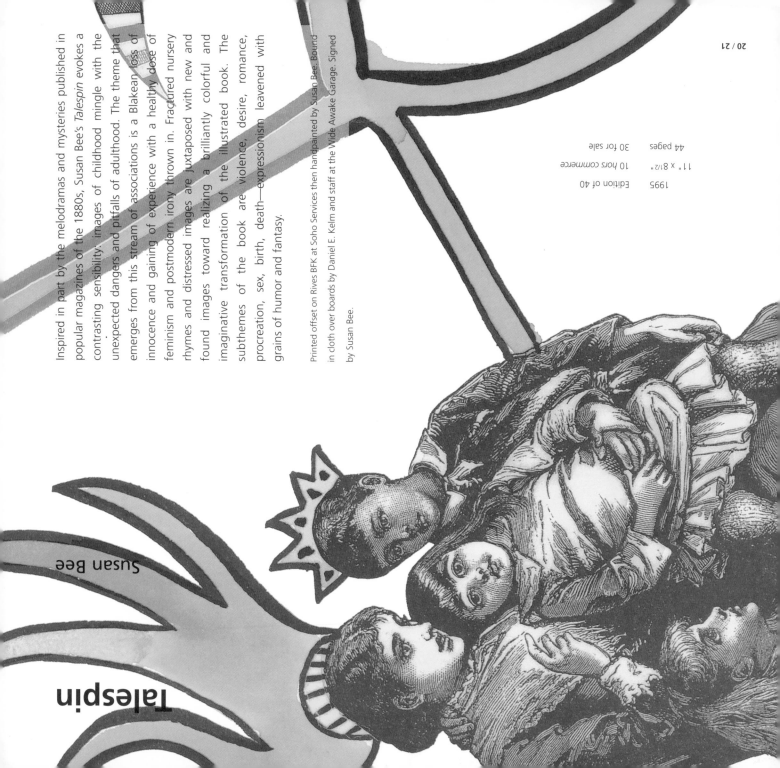

Inspired in part by the melodramas and mysteries published in popular magazines of the 1880s, Susan Bee's *Talespin* evokes a contrasting sensibility. images of childhood mingle with the unexpected dangers and pitfalls of adulthood. The theme that emerges from this stream of associations is a Blakean loss of innocence and gaining of experience with a healthy dose of feminism and postmodern irony thrown in. Fractured nursery rhymes and distressed images are juxtaposed with new and found images toward realizing a brilliantly colorful and imaginative transformation of the illustrated book. The subthemes of the book are violence, desire, romance, procreation, sex, birth, death—expressionism leavened with grains of humor and fantasy.

Printed offset on Rives BFK at Soho Services then handpainted by Susan Bee. Bound in cloth over boards by Daniel E. Kelm and staff at the Wide Awake Garage. Signed by Susan Bee.

1995
Edition of 40
11" x 8½"
10 *hors commerce*
30 for sale
44 pages

Susan Bee

Talespin

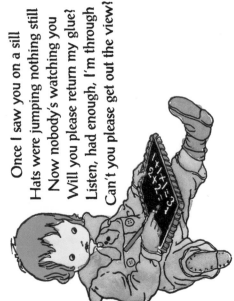

Little Orphan Anagram

Charles Bernstein & Susan Bee

Edition of 35	1997
10 hors commerce	11" x 8½"
25 for sale	40 pages

All the Tea in China

"I always find new friends"
But what becomes of the old
friends, slow bends?
Sooner or later, later than soon
Take a picture of the rune
The spoon she fly with loopy lies
What's to become of me or I?
What's to do — steep or sigh?

Once I saw you on a sill
Hats were jumping nothing still
Now nobody's watching you
Will you please return my glue?
Listen, had enough, I'm through
Can't you please get out the view?

"At what temporal and conceptual juncture do our 'Songs of Innocence' become 'Songs of Experience'? Susan Bee and Charles Bernstein take up these large questions in their collaboration *Little Orphan Anagram*."
Kenneth Goldsmith, Sulfur

"Artist Susan Bee, preoccupied with images from the end of the nineteenth century, paints heroines in high-necked dresses, anatomically correct nudes in high-heeled shoes, images from ladies' magazines and early twentieth-century children's books....On the first page, Charles Bernstein's postmodern language nursery rhymes announce, 'My breast is bursting with pride to see my son go down the slide.' And the verse continues its own brand of mockery in its pseudo-cautionary trip through the wild, wilder, and wildest of Susan Bee's paintings."
Corinne Robins, American Book Review

Printed on Rives BFK by Joe Elliot at Soho Letterpress then handpainted by Susan Bee. Bound in cloth over boards by Daniel E. Kelm and staff at the Wide Awake Garage. Signed by Charles Bernstein and Susan Bee.

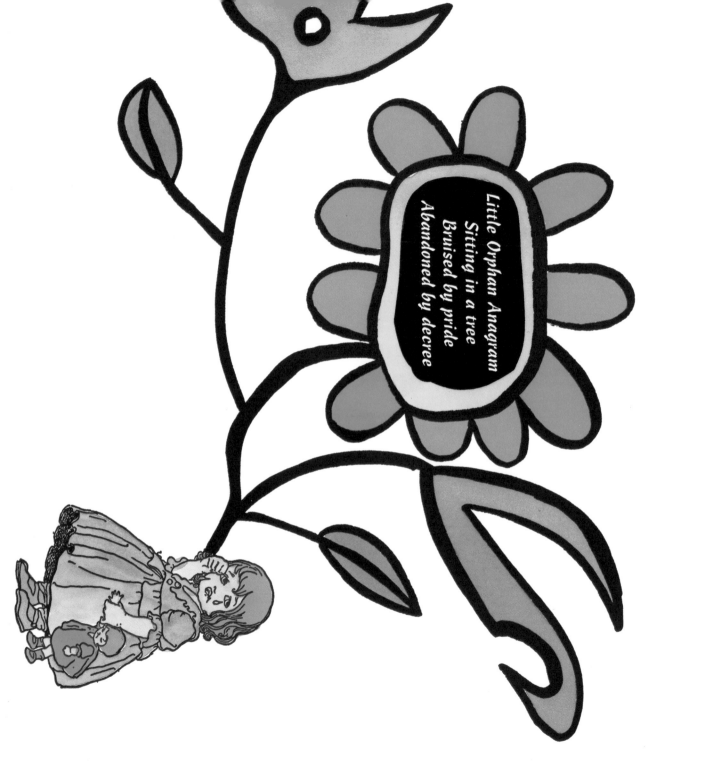

Little Orphan Anagram
Sitting in a tree
Bruised by pride
Abandoned by decree

I've faxed you, e-mailed, left a
sent you a letter, & you still don
Your routine is my Gatorade, lik
coop you call your gray matter,
upside your nasal canal. To you
means another franchise locatio
sure, or you'll fall off and find
paddling on all fours, if you can
that high. You give intuition a
your instinctual response invaria
the most harm, especially where
Your idea of morality is to drive
to a homeless shelter. But, like
always says, the shortest distan
is to sit down and wait till tomo
when you'll have any number of
to find something eto do.

Log Rhythms

Charles Bernstein & Susan Bee

Edition of 500

1998

11" x 8½"

24 pages

In this book, Susan Bee sets and illustrates a long serial poem by Charles Bernstein, offering a running visual dialogue with the poem's textual acrobatics. Together they explore the psychopathology of everyday life: at times dark, at times dizzyingly demented, swerving from the wildly comic to the searingly political and from the whimsical to the elegiac. **"Nursery rhymes have a special significance in Bernstein's verse: they offer both a reminder that ideology coos at us over the crib and a potential liberation from conventional sense, a dawning awareness that the world is still to be made."**

Paul Quinn, *Times Literary Supplement*

Printed offset on Warren's Lustro Dull by Brad Freeman. Cover designed by Philip Gallo and Susan Bee, then laser printed at The Hermetic Press. Saddle-stitch paperback.

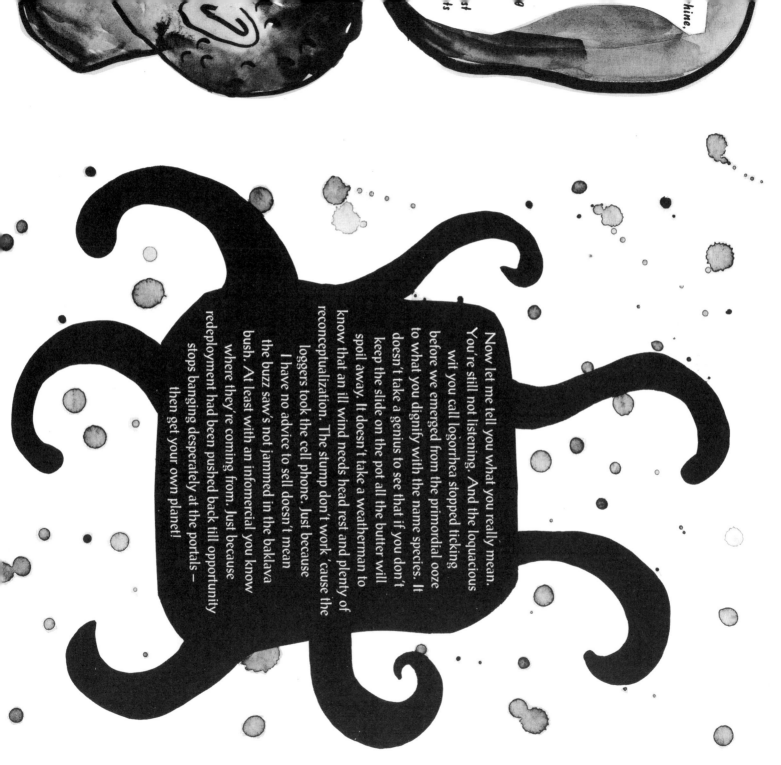

Now let me tell you what you really mean. You're still not listening. And the loquacious wit you call logorrhea stopped ticking before we emerged from the primordial ooze to what you dignify with the name species. It doesn't take a genius to see that if you don't keep the slide on the pot all the butter will spoil away. It doesn't take a weatherman to know that an ill wind needs head rest and plenty of reconceptualization. The stump don't work 'cause the loggers took the cell phone. Just because I have no advice to sell doesn't mean the buzz saw's not jammed in the baklava bush. At least with an infomercial you know where they're coming from. Just because redeployment had been pushed back till opportunity stops banging desperately at the portals — then get your own planet!

Ted Berrigan:
An Annotated Checklist

Aaron Fischer

1998
10" x 7"
70 pages
Edition of 1052

A poignant introduction by Lewis Warsh sets the stage for this fascinating look at the inner workings of the literary underground as seen through the publications of one poet at its epicenter. More than a mere checklist, this book is peppered with anecdotes from many of Ted Berrigan's friends and publishers, including Anne Waldman and Ron Padgett. Illustrated with twenty-seven literary pictures—previously unpublished collaborations by Mr. Berrigan and painter George Schneeman made in the late 1960s and early 1970s.

"The Checklist gathers together the many separate strands of the poet's work, and also does more, telling the 'story' of Berrigan's books and, in a sense, the period in which they appeared and the many diverse people connected with Berrigan. This is a welcome volume on a colorful figure in American literary history."

Henry Wessells, *AB Bookman's Weekly*

"Many, many thanks for the Ted Berrigan Checklist. It is superbly done. In all my years, I have never seen anything that could compare with it."

Robert Wilson, Phoenix Book Shop, author of *Modern Book Collecting*

Designed by Philip Gallo. Illustrated in color and black & white. Printed offset. One thousand copies bound in paper wrappers; fifty-two copies casebound in boards by Jill Jevne, with an original artwork by George Schneeman. Of the fifty-two copies in boards, twenty-six are signed by Ted Berrigan, Lewis Warsh, Mr. Schneeman and Aaron Fischer; the remaining twenty-six are signed by Mr. Warsh, Mr. Schneeman and Mr. Fischer.

Peace Detroit. Alternative Press, [1970].
Broadside (8½ x13"). Printed letterpress by
Ken and Ann Mikolowski at the Alternative Press.

According to Ken Mikolowski, Berrigan wrote this poem for one
of his students, Franny Winston, who was killed in a car accident.
Berrigan was teaching at the University of Michigan at Ann Arbor
when Mikolowski first met him. "We had just set up the press in
Detroit and Ted came down to visit and gave us this poem."

Guillaume Apollinaire Ist Tot.
Frankfurt, Germany: März Verlag, 1970.
Wrappers with acetate jacket.
Bilingual edition with photographs.
Drawings by Joe Brainard and George Schneeman.

This book features poems by Berrigan (printed in English with
facing text in German); prose works and letters (German only);
collaborations with Ron Padgett (German); and essays by Tom
Clark, Ron Padgett, and Alan Kaplan. The title for this book is
taken from "Sonnet 37": "It is night. You are asleep. And beautiful
tears / Have blossomed in my eyes. Guillaume Apollinaire is dead"
("Es ist Nacht. Du schläfst. Und schöne Tränen / Haben in meinen
Augen geblüht. Guillaume Apollinaire ist tot.")

32

In The Nam was first made as a one-of-a-kind collaborative book in 1967-68. The original was passed back and forth between Ted Berrigan and George Schneeman, remaining in the hands of one or the other for weeks or even months at a time—poet and artist each adding, subtracting, working over words and images. The materials used were pen and ink, white acrylic paint and collage. The work was made primarily for the amusement of the collaborators, thus the "finished" project languished in a drawer in Mr. Schneeman's studio on St. Mark's Place for thirty years. Produced when the Vietnam War was rapidly escalating, this work is by turns surreal, incisive, hip, outrageous, cartoon-like, flip, sinister, humorous, dreamy, sarcastic and witty—always right on target—a vivid evocation of the times and the broad range of emotional responses to the War.

"With its constant layering of word and image and the cumulative impact of overlapping and colliding forms, collage is essential to this work. All sheets make use of it, and there is often a playful, old-fashioned tone to the pastiched elements—an equestrian magazine from the 1930s, for instance, is followed up by colorful, outdated print advertisements or bits of gift wrapping….The words derive their impetus from the visual ground; they are at once part of and a commentary on their situation in this visual-verbal complex."

Vincent Katz, Art on Paper

This edition is a simulation of the original. Printed letterpress from magnesium plates on Rives 300 gm paper by Philip Gallo at The Hermetic Press. Folded sheets housed in a plexiglass slipcase. Signed by George Schneeman.

Ted Berrigan & George Schneeman

In the Nam What Can Happen?

1997 Edition of 70

9¹/₄" × 8¹/₄" 20 hors commerce

16 pages 50 for sale

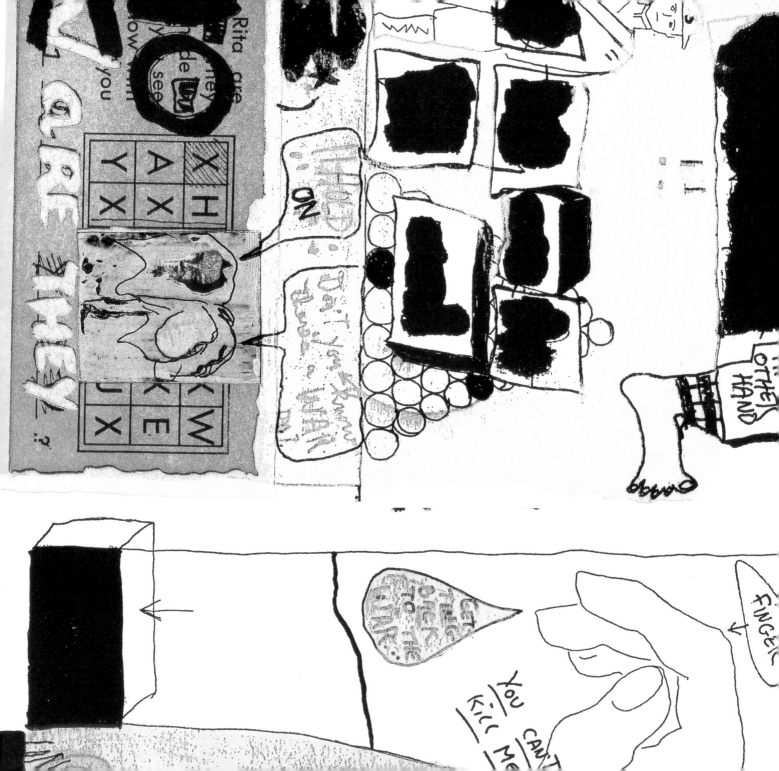

Lunaria

bill bissett

From the pages of bill bissett's *Lunaria* come moments filled with searching and illumination. Sights and experiences from "les moon rayze" to "happeeness in ths short life" are woven into expressive drawings and explorations of language.

"[In bill bissett's books] the surface is not contextualized— it is not a surface of, under, or around anything—but the flow of force itself, obliterating insides and outsides, and freeing writing from the domain of the categorical....The books are not to be conceived solely from the viewpoint of their utility, but also from their character as flow, intensity and force: the urge of the words through and between the books, as if language, whilst inhering in their formats, releases a non-verbal energy above their surface."

Steve McCaffery, "Bill Bissett: A Writing Outside Writing"

"spellings changing as nuance implikaysyuns shift altr retain its theyr xpressiv being yes langwage also not statik diffrent spellings reflekting elusidating different ranges ovr time it being plural parts uv itselvs resonate mor enchance partik ularize mor aspekts uv the shiftings uv kours creating manee aspekting awarenesses espeshulee uv thos realms wch ar not offishulee in th statements thru th spelling behaving mor n mor phoentikalee we can see demonstraysyuns uv how peopul oftn dont reelee meen what they ar saying n sew on inklude othr radikalee diffrent opsyuns sum evn kontra dicktoree 2 or with th surface meenings sew that th voisings radiate n within spreding in2 a largr hemispheer..."

bill bissett, from an interview with Adeena Karasick

Printed letterpress then handpainted and signed by bill bissett.
Bound in cloth over boards.

| 2001 | ca. 11" x 8½" | ca. 88 pages |
| Edition of | ca. 40 | |

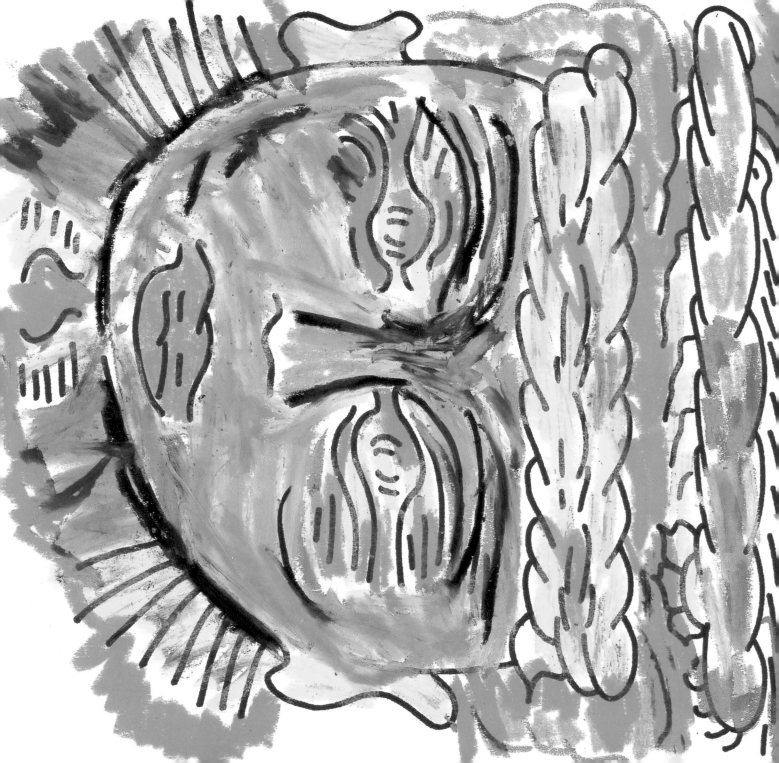

An affinity with William Blake's sense of the integrity of the artist's vision and self-created world has been a salient characteristic of Barbara Fahrner's work throughout her career. In this book, Philip Gallo's unconventional "cyber-punk deconstructionist typography" embodies the stylistic eccentricities of Blake's drawings elliptically respond to its powerful statement. The commanding dimensionality and craftsmanship of this volume equally reference Blake's impassioned text as well as his own work as an artist/publisher.

"Fahrner sees her use of texts such as this one of William Blake's as a conversation between herself and another artist, a process of exchange 'like talking to a friend.'"

Johanna Drucker

"Just a wonderful book!"

Marvin Sackner

Text designed and printed letterpress by Philip Gallo at The Hermetic Press. Original drawing and painting by Barbara Fahrner. Bound in cloth and paper over boards by Daniel E. Kelm and staff at the Wide Awake Garage. Housed in a cloth-covered clamshell box by Jill Jevne. All copies are signed by Ms. Fahrner and Mr. Gallo. In addition to the book, two Blakean drawings by Ms. Fahrner were printed and handcolored and, mostly, given away with copies of the book.

William Blake, Barbara Fahrner & Philip Gallo

The Marriage of Heaven and Hell:
A Reading & Study

1993

12½" x 12"

11 hors commerce

50 pages

Edition of 41

30 for sale

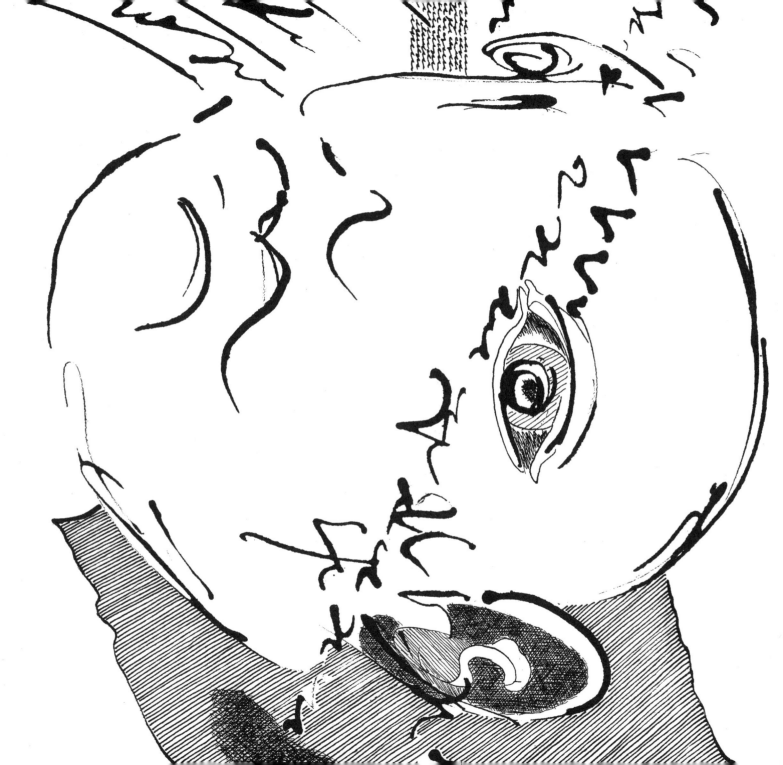

In addition to a checklist and bibliographies of work by and about Joe Brainard, this exhibition catalog includes published and unpublished writings by Mr. Brainard, interviews, letters and the essays, "Joe Brainard" by John Ashbery, "Acts of Generosity" by Constance Lewallen and "Joe Brainard's Quiet Dazzle" by Carter Ratcliff. Ms. Lewallen chronicles Joe Brainard's formative years in Oklahoma and moves to New York City and Boston, his involvement with Pop Art, assemblage and painting, and his literary and artistic associations. She writes: **"His collaborations with writers [including Ted Berrigan, Kenward Elmslie and Frank O'Hara] took many forms, from comic strips to book covers and illustrations....Not since the nineteenth century can we find such a rich joining of poetry and art."**

"Joe was a creature of incredible tact and generosity. He often gave his work to friends but before you could feel obliged to him he was already there, having anticipated the problem several moments or paragraphs earlier, and remedying it while somehow managing to deflect your attention from it."

John Ashbery

Designed by Julie Harrison. Illustrated in color and black & white. Printed offset. Bound in stiff wrappers with dustjacket.

ca. 176 pages

Edition of ca. 2500

2001

10½" x 8"

Constance M. Lewallen

with essays by John Ashbery & Carter Ratcliff

A Retrospective

Joe Brainard:

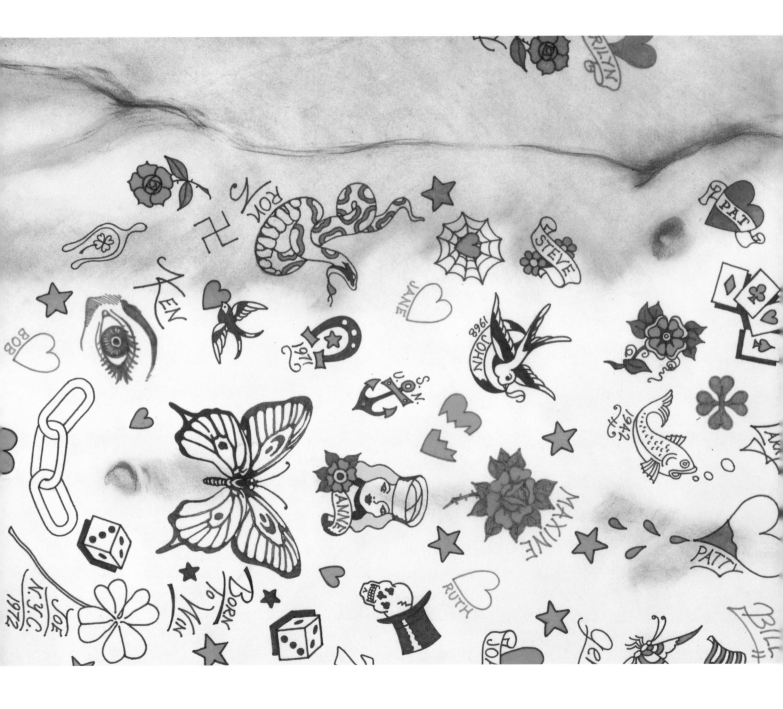

From The Book of Legends

Jane Brakhage

1989 Edition of 180

8 1/2" x 5 5/8"

38 pages

Maya Deren, Joseph Cornell, Charles Olson. Each of these artists discovered and established new means for expressing their experience through forms imbued with the original powers of myth, history and ritual. In this, her first book, Jane Brakhage (now Jane Wodening) explores the lives of these three American heroes with sensitivity, intelligence and compassion. Drawing from the traditions of King Arthur's Court, she arrives at a vivid style all her own in telling these contemporary legends of boldness and creativity.

Designed and printed letterpress on Frankfurt Cream by Philip Gallo at The Hermetic Press. Frontispiece contains a three-color mezzotint. Eighty copies bound in paper over boards by Katherine Kuehn. One hundred copies bound in paper wrappers by Jill Jevne and Jennifer Turrentine. Paste-paper for covers made by Claire Maziarcyzk. All copies are signed by Jane Brakhage.

Nods

John Cage, Barbara Fahrner & Philip Gallo

1991 Edition of 45

13¼" x 6¾" 10 *hors commerce*

44 pages 35 for sale

"*Nods* is a puzzle and a puzzle book. Like John Cage's famous composition 4'33"...it is straightforward in its presentation and yet puzzling, difficult to interpret, and challenging of one's accepted notions...everything changes the second time through."

Elaine Smyth, *Bookways*

"In *Nods*...no mimetic or clear relationship exists between image and text. Because the pictorial forms—in this instance, a mix of organic abstract shapes, some of which are based on the body—are not derived from the prose, the emphasis of the book is on invention, in the origination of new forms. The conventional design and organization of the book according to a serial structure is sometimes fractured and disrupted through imaginative

devices, such as varying and staggering the size and progression of pages."

Debra Bricker Balken, *Art Journal*

Nods is a collaborative work bringing together the diverse visions of preeminent American avant-garde composer John Cage, German artist and writer Barbara Fahrner and American poet and typographer Philip Gallo. Ms. Fahrner has excerpted texts from the rich body of Mr. Cage's published writings, ranging from everyday allegories of indeterminacy to philosophical writings on musical composition and dance. Each of these texts has been given a concrete or typographical treatment by Mr. Gallo. The writing and typography is complimented by Ms. Fahrner's printed linocuts and extensive handwork of drawn and painted images.

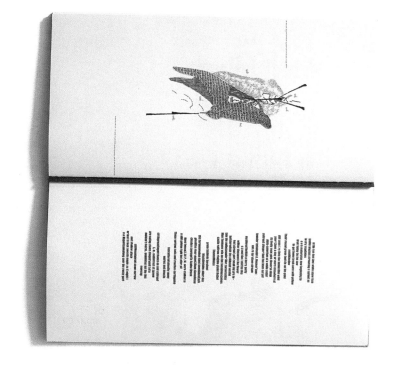

Designed and printed letterpress by Philip Gallo at The Hermetic Press. Handwork by Barbara Fahrner. Bound concertina style with paper over boards by Daniel E. Kelm at the Wide Awake Garage. Housed in a cloth-covered clamshell box by Jill Jevne.

Signed by John Cage, Barbara Fahrner, Philip Gallo and Daniel Kelm.

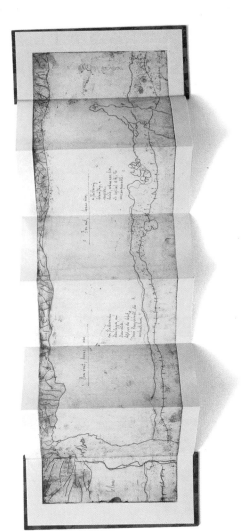

Four Poems

Through etchings and original drawings, Barbara Fahrner presents four of Paul Celan's poems of the "dark underground" in this set of accordian fascicles. Each of the poems is presented in German alongside an original English translation by Pierre Joris. The delicate, almost translucent paper, coupled with the subtleness of Ms. Fahrner's drawings, attribute to Paul Celan's work an aspect that is, in the words of the artist, "more a whispering than speaking." The boards of each book are covered in stunning papers mixing light and dark tones.

"Celan, the displaced Jewish poet from the Bukowina, who spent his life in Paris, France, but wrote in German, wrote in that language, the other tongue. He worked both the surface and the deep layers of German, he studied words, deeply, knew and studied dictionaries as few poets did. Any attempt to translate him has to deal with that aspect of his work...a poem can only translate into another poem—maybe a completely other poem, in a completely other language, in a completely other century."

Pierre Joris, "Celan/Heidegger: Translation at the Mountain of Death"

Printed and with handwork by Barbara Fahrner. Bound accordion style in paper over boards and housed in a cloth-covered clamshell box by Judith Ivry. Signed by Barbara Fahrner and Pierre Joris.

Paul Celan & Barbara Fahrner

1999		
Edition of 48		
8 hors commerce	9" x 7¹⁄₄" (box)	
20 for sale in the U.S.	8" x 3¹⁄₄" (each book)	
20 for sale in Germany		

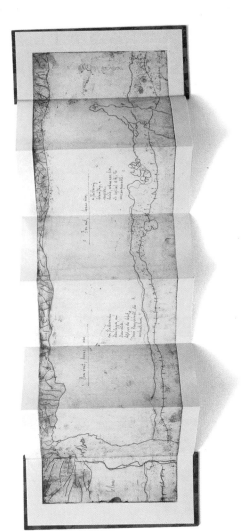

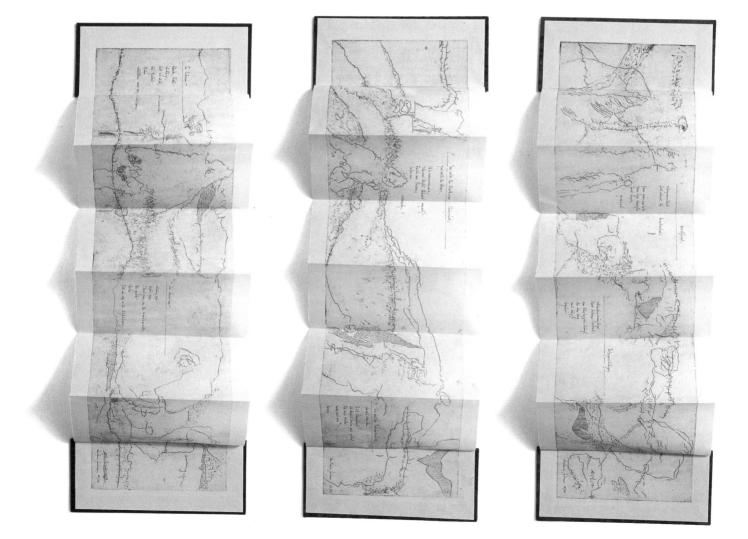

With a Pre-Face by Jerome Rothenberg, this book documents and expands upon the acclaimed exhibit (with two-thirds of the same title) at the New York Public Library, January-July 1998. An in-depth chronicle of the history of underground writing and publishing, A Secret Location justly recognizes the pivotal role of "the marginal" in shaping and fueling the forefront of American literature. Over eighty presses and magazines at the confluence of the New American Poetry and the Small Press Revolution are described, frequently in the words of the editor(s) involved. Checklists are also provided. Among those included are: *J, Open Space, White Rabbit, Oyez, Yugen, Floating Bear, Measure, Semina, Beatitude, Black Mountain Review, Origin, Poems from the Floating World, Something, Maps, Matter, Set, Something Else Press, Duende, Wild Dog, Umbra, Hambone, White Dove Review, C, Fuck You, Living Hand, Angel Hair, Big Sky, The World, Z, United Artists, Center, 0 to 9, Lines, Adventures in Poetry, Siamese Banana, Dodgems, Vehicle, Telephone, Mag City, L=A=N=G=U=A=G=E, Joglars, This, Tottel's, Hills, The Figures, Roof, Sun & Moon and Tuumba.*

Another 500 presses and magazines are cataloged in an appendix; there is also an extensive index, a fifty-page introduction by Mr. Clay and Mr. Phillips and a gate-fold pull-out literary chronology of the 1950-1980 period.

"Genuinely a must-have book."

Ron Silliman, UB Poetics discussion group <POETICS@listserv.acsu.buffalo.edu>

"Its vast and patient accumulation of information makes it an indispensible resource for the study of the New American Poetry, and its focus on the institutions of the little magazine and the small press offers a useful model for literary historians."

Michael Leddy, *World Literature Today*

Co-published with the New York Public Library. Designed by Marc Blaustein. Illustrated with over 200 black & white halftones. Printed offset. One thousand copies bound in cloth over boards; four thousand copies bound in paper wrappers.

342 pages

9" x 7"

1998 Edition of 5000

Steven Clay & Rodney Phillips

A Sourcebook of Information

Adventures in Writing, 1960-1980:

A Secret Location on the Lower East Side:

Literary Underground,

1965
- The Pacific Nation
- Death of Jack Spicer (age 40)
- Jim Lowell (Asphodel Bookshop) and d.a.levy arrested
- The Beard
- ...ix
- ...ts of Dawn
- anglia
- American Story
- the New
- Berkeley Poetry conference
- royal Albert Hall reading
- Some/thing
- Hermit Poems

1966
- Once series
- COACH HOUSE PRESS
- Poems Now
- Death of Frank O'Hara (age 40)
- Hanging Loose
- Flag Flutter and U.S. Electric Maps
- Astronauts of Inner Space
- BLACK SPARROW PRESS
- An Anecdoted Topography of Chance
- Angel Hair

1967
- o to 9
- Bean Spasms
- Caterpillar
- The Cities
- Open Skull
- Trout Fishing in America
- BeauGeste Press
- San Francisco Earthquake
- The World Anthology
- Earthquake
- Telephone
- The Ant's Forefoot
- Stones

1968
- T & G
- The Young American Poets
- The Poem in Its Skin
- Adventures in Poetry
- New York Times
- Giant Night
- Alcheringa
- An Anthology of New York Poets
- The Eastside Scene
- Juillard
- Tree
- I Remember
- Center
- The Tibetan Stroboscope
- 22 Light Poems
- The Truth and Life of Myth
- Death of d.a.levy (age 26)
- Elegiac Feelings American
- Tottel's
- 4 Ups and One Down
- Contexts of Poetry
- Toothpaste
- Lythium

1969
- On Bear's Head
- Manroot
- Naked Poetry
- Best and Company
- Stereo Headphones
- Catullus (translated by Celia and Louis Zukofsky)
- Empty Mirror
- A Little Anthology of Surrealist Poems
- Death of Jack Kerouac (age 47)
- Mulch

1970
- Air
- Concrete Poetry: A World View
- Truck
- Unnatural Acts

1971
- Death of Paul Blackburn (age 44)
- Stanzas for Iris Lezak
- Big Sky
- On the Mesa
- Unmuzzled Ox
- Memorial Day
- The Harris Review
- Moving
- Apparent death of Lew Welch (age 44)
- Mulch

1972
- Sixpack
- Parts of a Body House Book
- (first and only mimeo book ever reviewed in the New York Times)
- A Little Anthology of Surrealist Poems
- Contact (Philadelphia)
- Spanner
- Revolution of the word
- Shaking the Pumpkin
- Hinge Picture
- The Poetry Project Newsletter
- Jack Kerouac School of Disembodied Poetics
- Poets of the Cities
- Chicago
- Seventh Heaven
- The Crystal Lythium

1973
- This
- A Caterpillar Anthology
- Mohawk
- Open Poetry
- Z
- Life Notes
- Ring of Bone
- Poetics of the New American Poetry
- The "Water/Andrews" issue of Toothpick, Lisbon & the Orcas Islands

1974
- Rhymes of a Jerk
- Blues of the Sky Above
- Sun & Moon
- La-Bas
- Bombay Gin
- TUUMBA
- bill joubobe
- Little Caesar
- Roof
- The Countess from Minneapolis
- Doc(k)s
- A Hundred

1975
- A Prophecy
- The Ear in a Wheatfield
- Books of Jack Spicer
- Montemora
- Essaying Essays
- Adult Life of Toulouse Lautrec
- With Way
- Fast Speaking Woman
- Dental Floss
- All This Everyday
- Brilliant Corners
- Slinger

1976
- Oculist Witnesses
- The Collected Books of Jack Spicer
- 4, 3, 2 Review
- None of the Above
- Death of Wallace Berman (age...)

Bomb

Clark Coolidge & Keith Waldrop

2000 10" x 8"

Edition of 1500 48 pages

Bomb is a meditation on *Picturing the Bomb,** a book of photographs that document the Manhattan Project, Los Alamos. Clark Coolidge's thirty-page poem begins with epigraphs by Democritus, Gregory Corso and André Breton/Paul Eluard before embarking upon its own project of lucid investigation via an elliptical glancing narration: **"Put the bomb in a glass vase/add dust and forget."** *Bomb* is sharp, stark and rhythmic; Mr. Coolidge tangles with the dreamlike oddness of the photographs in fits and starts of language with an explosive beauty. Keith Waldrop's collages are literal reworkings of the original pictures: deep blacks and bright whites excavated from the book, remade here in the image of the poem.

Designed by Emily Y. Ho. Printed offset. Bound in paper wrappers. Twenty-six copies are lettered and signed by Clark Coolidge and Keith Waldrop. **Picturing the Bomb: Photographs from the Secret World of the Manhattan Project.* Rachel Fermi and Esther Samra. NY: Abrams, 1995.

He shut the kids down on the duck except one
with hands before his eyes he was the speller
of the week of all weeks in place on the master map
and twister of all heat and cold in the skull
and winters all the summers
he had jodpurs it is held, a surface of the sun in
his pen knife drawer the least of substances
there to form a skin

Got tired of stars on the ridden routes
put-up storefronts and falsity
bike towed into open fumbles on the metal train
a bomb with studs you could see it all open when you stood there
Teller makes a joke of reaching for his billfold
but they don't call them that anymore, do they
bombs?

She starred in the play had a blast next gone
a tribute with trumpet and trilobites at the waxing seals
this was called a pantomine posted as fun he will then bow
and present you with your baggage in one slatted dole
as she bends under a thermos a stick kicks her riser
hat to glove and one standard calf no beauty in wartime
acknowledged anyway but the interior kid hatches a smile
and the bomb comes gingerly loose

The Blind See Only This World:
Poems for John Wieners

William Corbett, Michael Gizzi & Joseph Torra, editors

Edition of 1000 2000 7½" x 5" 109 pages

"*The Blind See Only This World* honors the work of the poet John Wieners. It takes its title from the last poem in his sequence *Pressed Wafer*. In the biographical note Wieners wrote for Donald Allen's anthology, *The New American Poetry*, he remembered, **'I first met Charles Olson on the night of Hurricane Hazel, September 11, 1954, when I "accidentally" heard him read his verse at the Charles St. Meeting House (Boston). They passed out complimentary copies of *The Black Mountain Review #1*, and I ain't been able to forget.'** Many of those in this volume, whether they encountered Wieners first in his *Hotel Wentley Poems* (1959) or twenty-five years later in the two volumes of selected Wieners that Raymond Foye edited for Black Sparrow Press, can say that they too ain't been able to forget. Wieners has lived for the past thirty years on Joy Street on Boston's Beacon Hill."

William Corbett

Contributors to the anthology are: John Ashbery, Paul Auster, Amiri Baraka, Ed Barrett, Jim Behrle, Dodie Bellamy, Bill Berkson, Daniel Bouchard, John Clarke, Clark Coolidge, William Corbett, Robert Creeley, Tim Davis, Diane di Prima, Edward Dorn, Robert Duncan, Jim Dunn, Kenward Elmslie, Elaine Equi, Larry Fagin, Michael Franco, Benjamin Friedlander, Michael Friedman, Merrill Gilfillan, Allen Ginsberg, Michael Gizzi, Peter Gizzi, Robert Glück, John Godfrey, Barbara Guest, Thom Gunn, Jim Harrison, Lee Harwood, Stratis Haviaris, Fanny Howe, Susan Howe, Kenneth Irby, Stephen Jonas, Robert Kelly, Kevin Killian, Ann Kim, August Kleinzahler, Joanne Kyger, Gerritt Lansing, Frank Lima, Nathaniel Mackey, Bernadette Mayer, Gail Mazur, Duncan McNaughton, Askold Melnyczuk, Ange Mlinko, Charles North, Jawn P, Ron Padgett, Michael Palmer, Jack Powers, Michael Rumaker, Andrew Schelling, Charley Shively, Aaron Shurin, Cedar Sigo, Charles Simic, James Tate, Joseph Torra, Paul Violi, Anne Waldman, Lewis Warsh, Carol Weston, Dara Wier, Elizabeth Willis, John Yau, Geoffrey Young and John Wieners.

Co-published with Pressed Wafer. Designed by Amber Phillips. Cover photograph of John Wieners by Allen Ginsberg. Printed offset. Bound in paper wrappers.

"Robert Creeley and Elsa Dorfman bring us the real news of the different ways the word 'family' has been made to leap beyond its lexical meanings. Poet and photographer register how family is being re-envisioned by those who live as individuals within a 'securing center.' Beginning with, and subverting, 'I wandered lonely as a cloud,' William Wordsworth's quintessential Romantic image of the self, Mr. Creeley writes a poem whose formal structure, its interlocking, echoing pattern of rhymed quatrains challenges our assumptions about the legacy of Romantic and Modernist poetry. It is not that their legacy or the family should endure in some rigid manner; it's that they have changed and are changing still."

John Yau, author of "Active Participant: Robert Creeley and the Visual Arts"

"Dorfman's portraits project a clothed nakedness, the blunt familiar fact of physical presence. She does this by a contrivance so simple as to be beyond words. The proof is in the photographs."

William Corbett, artsMEDIA

"Now and again a collaboration such as this book can prove an absolute delight. I've known Ellie for years and love the way her portraits so touch the actual presence of people. No one's afraid of her—no one defensive or other than open. So to work with her in the way this book permitted was pure delight—and the poem I wrote in response to the photographs she'd let me choose really wrote itself, following the fact of the families, in all their diversity, that I was thus enabled to see."

Robert Creeley

Designed by Philip Gallo. Printed offset. Bound in paper over boards.

80 pages

8¼" x 6¼"

Edition of 2000 1999

Robert Creeley & Elsa Dorfman

En Famille

Naylor, Ted, Alexander, Nick. March 30, 1995.

Originally published in 1838, Edgar Allan Poe's engaging short story *Ligeia* "...invites a diversity of readings [wherein] one feels confidence making a determination for one's own necessary uses." (from "A Note on *Ligeia*" by Robert Creeley). Here, the material has been translated into an operatic context, Mr. Creeley's first libretto. As Mr. Creeley excerpts from Poe's narrative in brief: "the narrator/hero meets the exceptional Ligeia, is captivated by her, marries her, and becomes entirely influenced by her commanding powers of intellect and beauty. Then she dies harshly, resistingly. And then, after a brief time, the hero remarries, and the cycle is almost immediately repeated but without seeming resistance, which leads to the intense conclusion, the recreation of Ligeia in the corpse of the Lady Rowena." *Ligeia: A Libretto* makes use of the emphasized pattern of Poe's narrative; his vocabulary, rhythms and rhetorical emphasis inform Mr. Creeley's compositional strategy. Ultimately, one is left with a new and unique work beautifully transformed for the stage. Alex Katz made the drawing for set and costume design toward the eventual production of *Ligeia*.

Designed and printed letterpress by Philip Gallo at The Hermetic Press. Bound in cloth over boards by Jill Jevne. All copies are signed by Robert Creeley and Alex Katz.

40 pages	100 for sale
13 1/4" x 6 1/2"	35 hors commerce
1996	Edition of 135

Robert Creeley & Alex Katz

Ligeia:
A Libretto

Woman

O God!–
O God! O Divine Father!–
Shall these things

be always so?–
Shall this Conqueror
be not once conquered?

Are we not part
and parcel
in Thee?

Who–who knoweth
the mysteries
of the will

with its vigor?
Man doth not yield to the angels,
nor unto death

utterly, save only
through the weakness
of the feeble will...

Chorus

«Man doth not yield himself to the angels,
nor unto death utterly,
save only through the weakness of his
feeble will.»

Ligeia!

Chorus / Man
(with Man then continuing as if reading)

She died;–and I, crushed into the very dust
with sorrow,
could no longer endure the lonely desolation
of my dwelling
in the dim and decaying city by the Rhine.

*(Interval for set shifting or the like. Here is the
natural midpoint. Therefore music here bridges
with the following either projected as with the
lines preceding, else read by the Man)*

After a few months, therefore,
of weary and aimless wandering, I purchased,
and put in some repair,

an abbey, which I shall not name,
in one of the wildest, least frequented
portions of fair England.

The gloomy grandeur of the building,
the almost savage aspect
of the domain, the many melancholy memories
coincident

"It was John Yau who had introduced us some years ago in New York. Archie [Rand]'s humor, quickness, and lack of pretension much attracted me, but the chance to work with him was curiously hard to come by despite his own play with narrative texts and old-time comic book formats. Then Archie sent me a cluster of xeroxes of drawings he'd been doing and suggested I might do some text or texts to go with them. It was an instantly attractive proposal, but, again, it wasn't until Archie actually came with his wife Maria to Buffalo—he was to check a 40-by-60-foot wall at the Castellani Museum in Niagara University, so as to do something with me for a show of my collaborations—that anything really happened. How it did still amazes me. I knew Archie had brought with him the litho sheets with the fifty-four drawings. I had tried a few brief quatrains to see how that form might work in context with the xeroxed images he'd sent me earlier. But when we went into a back room at the museum, and Archie took out the lithosheets and asked if I might try to do a text for each image there and then, I was intimidated, not to say, shocked. Still I said I'd try, and so we set out. The procedure was for Archie to slide me an image on the litho paper. I'd try a take or two to get the feel, writing on a usual sheet of typing paper, then resolve on a particular quatrain, put it with the litho sheet related—and on to the next. So we worked through the afternoon until, finally, all fifty-four poems were finished. Then I copied each poem under its respective image on the litho sheet. I recall we pretty much closed up the place—as ''twere in dream! I felt as if I had been in some fantastic traffic of narratives, all the echoes and presences and situations—like very real life indeed. I loved the almost baroque feel of the drawings, the echo of old-time illustrations and children's books. Whatever, Archie's sure got me. The rest you can judge for yourself."

Robert Creeley

Printed offset. Bound in paper wrappers. Twenty-six copies are lettered and signed by Robert Creeley and Archie Rand.

Edition of 2001
ca. 2000
ca. 9" x 6"
ca. 100 pages

Robert Creeley & Archie Rand

Drawn & Quartered

And have you read
my humours clear
and what's more
could you my dear?

Simon Cutts, writer, artist, designer and founder of Coracle Press and Gallery, offers a generous helping of recent writing in this collection of poems, 1988-1998. Within the pages one finds "addendum erratum," a bookmark with a poem (loose within), as well as "an ode for the recovery of an olympia 66 typewriter" and "The Rubber Stamp Mini Printer Series 1." Mr. Cutts's approach to the tradition of printing, a subject and field that this book shows has played a significant part in his life, is both serious and personal while maintaining a playful attitude. His language is spare and vivid, often illuminating small details within a simple line and quickly presenting an idea or moment. The poems within these pages offer a glimpse into a life that admires a printing press as much as the natural world and a page with words as much as the personal world.

"Every once in awhile Simon Cutts makes a pure and simple poem (nothing is *pure* and nothing is *ever* simple, so what?)—a work I have been waiting for all my life to see."
Jonathan Williams, "A Particularly non-Arty Response to the Coracle Man"

Co-published with Coracle Press. Designed by Amber Phillips. Printed offset. Notchbound in paper wrappers with dustjacket.

96 pages

7" x 5¹/₂"

2000 Edition of 500

Simon Cutts

A Smell of Printing:
Poems 1988-1998

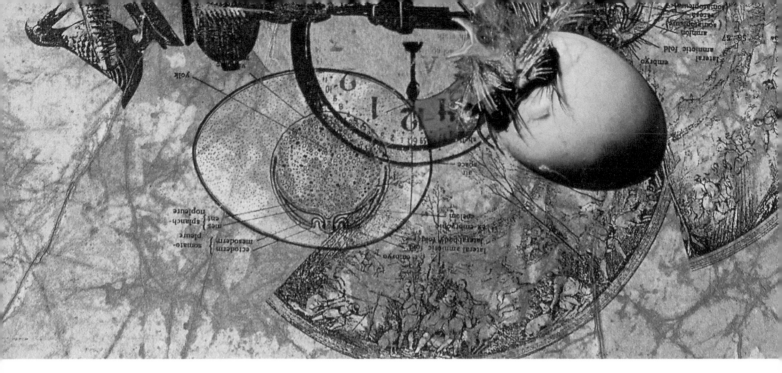

Scrutiny in the Great Round

Tennessee Rice Dixon

1992	Edition of 22
11" x 8"	5 hors commerce
26 pages	17 for sale

Rooted in biology and informed by prophecy, this book traces an alchemical lifeline in time: from before conception to after birth. A range of evolutionary characteristics, from sacred to profane, are here evoked through a visual narrative of intense investigation, potent with beauty. A host of images, from seventeenth-century alchemical engravings to twentieth-century high school science book illustrations, editioned on the copier, provide the background for Tennessee Rice Dixon's original collage, drawing and painting. Hinting at autobiography, *Scrutiny in the Great Round* is concerned with the imagery of fertility, reproduction, birth and growth. The paper has a delicate, densely worked surface with photomontages, drawings and paintings.

"Dixon's montages draw on their own distinctive visual vocabulary, as well as her own method of structuring pictorial space. Dixon structured a narrative throughout her book, a tale in which the process of 'scrutiny'—searching, exploring, examining the forms of procreative energy, results in the generative process of production."

Johanna Drucker

Photocopied, with handwork, painting and collage by Tennessee Rice Dixon. Bound by Daniel E. Kelm and staff at the Wide Awake Garage. Housed in a cloth-covered clamshell box by Jill Jevne. Signed by Tennessee Rice Dixon.

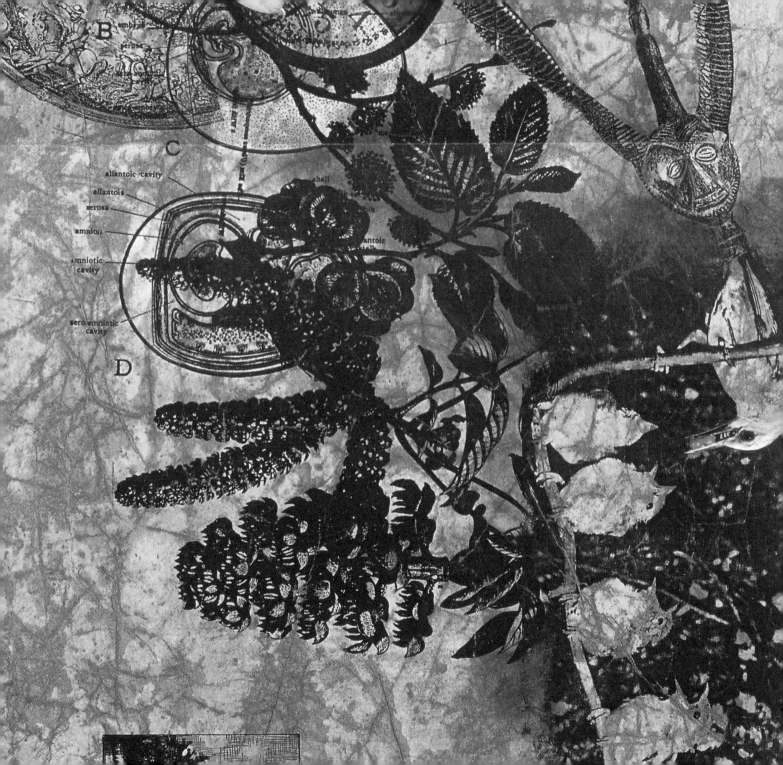

B

C

allantoic cavity

allantois

serosa

amnion

amniotic
cavity

sero-amniotic
cavity

D

Mesmer: Secrets of the Human Frame

Toni Dove

1993 Edition of 60

11" x 8" 10 hors commerce

64 pages 50 for sale

"Toni Dove's *Mesmer*, after having undergone several metamorphoses (computer-driven slide and sound installation, radiophonic work, essay), has been recreated as an artist's book. This work, which refers to itself as 'a fractured icon, an unstable portrait,' is both a study of the construction of female identity and an elegy to the intersecting nineteenth-century origins of psychoanalysis, cinema and industrial technologies....Through a dialogical collage-montage in the voices of Freud, Dora, Echo and a Cyborg Angel...*Mesmer* is a mediatic robotic machine that investigates how the soul is nothing but corporeal facade and speech act."

Allen S. Weiss, *Art + Text*

"The female body is here represented without being presented as an object with no voice. The figure is veiled, armored, dissected and x-rayed, but never viewed as a mute body. Here is a vocal presence and a carnal absence."

Toni Dove

Using both transparent and opaque metallic papers (including a three-dimensional centerfold pop-up), the work's many layers create a rich and densely visual reading experience.

Printed offset in several shades of metallic ink by Lori Spencer at the Borowsky Center for Publication Arts. Bound in metal by Daniel E. Kelm and staff at the Wide Awake Garage. Housed in a slipcase by Jill Jevne. Signed by Toni Dove.

CYBORG ANGEL

"Because I know you are obstinate and your neck is an iron sinew and your forehead brass"
(Isaiah 48:4)

Macromolecular circuitry to the optic nerve.
Visual system collects information in two largely specialized sensory receptors – the eye.
The retinal net sends information via optic nerve to visual cortex.

*Data reconstructed into unintelligible visual image.
Stored as AI memory, ROM package – washing data storage
wired with biosynthetic neurons in the auditory cortex.
Auditory center interprets signals and stores as AI memory,
ROM package. Backup bio/neural system –
video and audio.*

Dissemulation, disarms, aphonia, writing or disturbance of affect,
aphasia – word salad, jargon aphasia, disconnection syndromes,
rapid comprehension of multiple input channels,
increased geographical access, increased information access,
electronic stimulation of memory and language systems.

*Oh, I was floating, hovering overhead, for never touching the ground,
porous twin bones keeping me light on the air
but never touching, never touching the ground.
I ate a peach and it spoke to me.
I float free – made love like a dragonfly coupled in the air.
It's always been, or was there so before,
I keep losing my focus, slipping back.
Sometimes it's dark and lights flash way in the backs of my eyes
and I reach out...
but nothing's there.*

The Android is
divided into four
MAJOR PARTS:

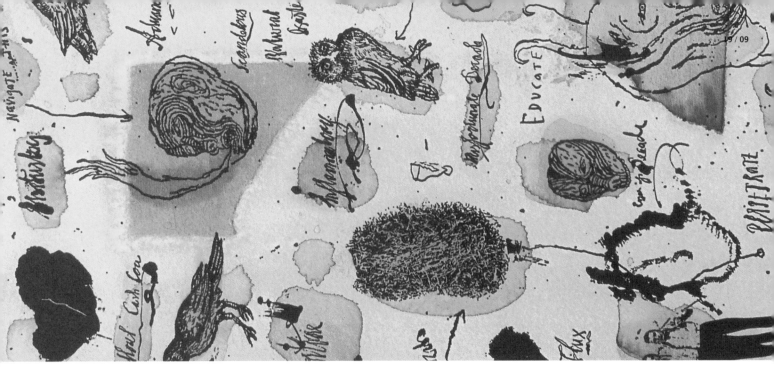

Too Much Bliss

Henrik Drescher

Edition of 41	1992
16 hors commerce	12" x 9"
25 for sale	46 pages

"I've been circling this book like a suspicious cat for the past month, not daring to form an opinion about an object that is so much an extension of the artist that only his physical presence is missing. Henrik Drescher...has poured his guts into *Too Much Bliss*. There they are, in the form of contorted creatures, floating body parts, exploded decoration, splattered watercolor, collage, cryptic messages written in an elegantly clumsy hand, sheets of latex, and 'ornamentalities' by his wife Lauren. Drescher describes all this as 'scars, tattoos, cracks, memories, impressions, flashbacks, forgotten instructions,' or as is written on the last page, 'everything at once.'"

Barbara Tetenbaum, Bookways

In the words of Johanna Drucker, "this book has the look of some manic, encyclopedic new age Sears and Roebuck mail order catalogue of all the elements that ever existed in the course of organic history and human memory."

Printed letterpress on Rives BFK by Philip Gallo at The Hermetic Press with collage, drawing, cutting, painting and latex by Henrik Drescher. Bound in cloth over boards by Daniel E. Kelm and staff at the Wide Awake Garage. Housed in a cloth-covered clamshell box by Jill Jevne. Signed by Henrik Drescher.

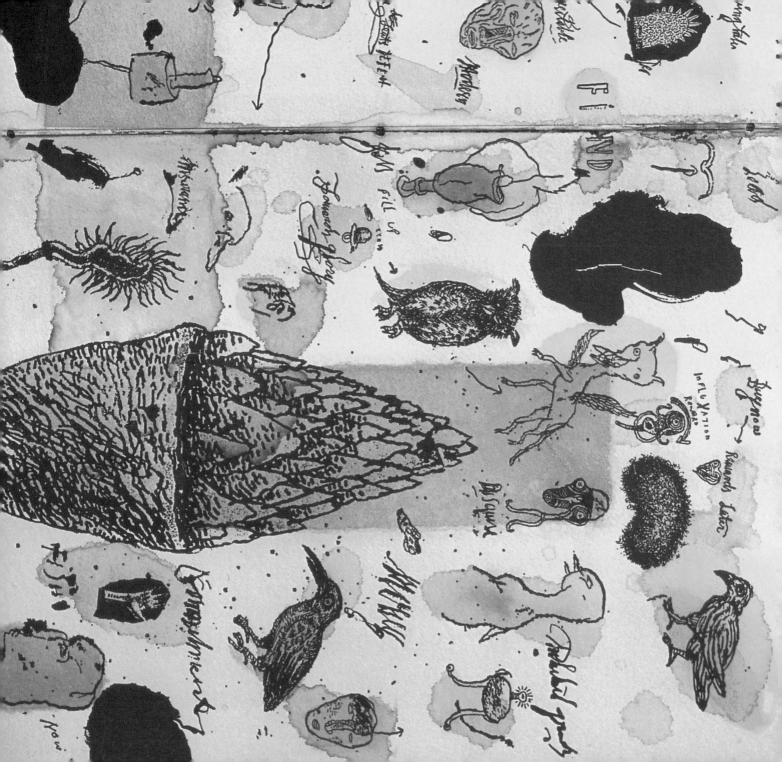

The first full-length study of the development of artists' books as a twentieth-century artform, this book situates artists' books within the context of mainstream developments in the visual arts and is designed to raise critical and theoretical issues as well as provide an historical overview. Johanna Drucker explores more than 200 individual books in relation to their structure, form and conceptualization.

"[Ms. Drucker] locates the artists' book, in all of its multitudinous aspects, within every significant modern movement and draws on an extensive bibliography of scholarly references to reveal the philosophical and artistic connections among the several emerging avant-garde movements of the early twentieth century...The book vastly expands our understanding of the interdependence of structure and meaning in artists' books, and establishes a more rigorous standard of criticism and analysis for the genre."
Buzz Spector, Art Journal

"We have been waiting for this book for a long time, and I tell all my readers, that this is the book to buy, read, and re-read, keep and share. This will be a major reference for all thinkers of the book for a long time."
Judith Hoffberg, Umbrella

"For now The Century of Artists' Books is sui generis."
Tom Trusky, *Afterimage*

Designed by Brad Freeman. Illustrated with over 200 black & white halftones. Printed offset. Four thousand copies bound in cloth over boards (1995); three thousand copies bound in paper wrappers (1997).

First edition 1995 & 1997
of 4000 9¹/₄" x 6¹/₄"
Second edition 377 pages
of 3000

Johanna Drucker

The Century of Artists' Books

Tatana Kellner, **50 Years of Silence,**

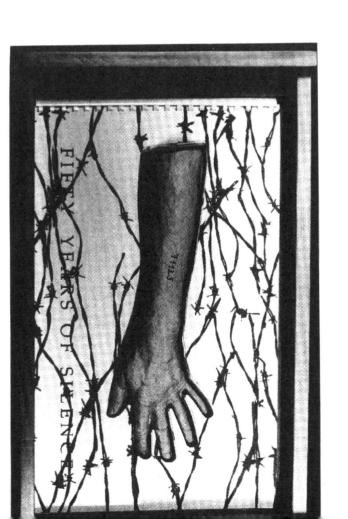

Tatana Kellner, **50 Years of Silence,**

e edition, so

se of aura in
rk is Tatana
men's Studio
s of Silence
the book is
comodate a
s arm. Flesh
efers to her
concentra-
inside back
experience,
away, and as
arent.3 The
diminishing
latile mater-
d against the
all the more
of relations
er's story in
on the verso
t of the text,
cut opening)
age, the arm
c, grotesque,
ody has been
ult the book
book is com-
ionistic, it is
narrative and
ematic con-

This book is a sort of Johanna Drucker "reader." Yet, instead of anthologizing from published books, *Figuring the Word* collects writings published in obscure academic and literary journals or delivered as talks or interviews. The book contains several sections (each with several chapters) including "Writing as Artifact," "Visual Poetics," "Artists' Books Past and Future," "The Future of Writing" and "Personal Writing."

"Figuring the Word is a work of poetics rather than criticism or theory in that these essays are the products of doing as much as thinking, of printing as much as writing, of designing as much as researching, of typography as much as composition, of autobiography as much as theory. The mark of the practitioner-critic is everywhere present in these pieces:...*Figuring the Word* is a wide-ranging collection of Ms. Drucker's essays from the early 80s to the present. Written in a variety of styles and presented in a variety of formats, the book reflects many divergent aspects of her work and thinking, while at the same time demonstrating how cohesive her project has been."

Charles Bernstein, from the Introduction

Designed by Johanna Drucker. Illustrated with black & white halftones. Printed offset. Bound in paper wrappers.

312 pages

8¹⁄₂" x 5¹⁄₂"

1998

Edition of 3000

Johanna Drucker

Essays on Books, Writing and Visual Poetics

Figuring the Word:

her late twentieth century work in the Unit
towering British scholar-book artists of
William Blake of the late eighteenth centur
late nineteenth. Like these men of letters,
books bends and stretches the nature of art
ventional generic constraints. She question
codings of the intellectual, the polymath,
Indeed, Drucker is more a satirist than a vi
in, rather more than reviling, the "carniva
For all its extraordinary detail and formidab
is rigorously anti-systematic, emblematic

rd cut stone…

their passin…

eated male

ced the cor…

eros at the

e farmland.

ST OF LIV…

into the air

Calling in cliches to aid in their

rvens
cks

"[Johanna] Drucker's autobiography becomes a kind of hypertext, a set of possible verbal-visual paths that suggest further possibilities in the writing of her story."

Marjorie Perloff, *Harvard Library Bulletin*

The History of the/my Worl(l)d provides a striking alternative to the familiar telling of historical events. Johanna Drucker's account of mythic and major moments in the course of western civilization marches roughshod over received traditions. This work combines references and irreverence, humor and insight, poetic language and an eclectic imagination. The combination of typographic innovation, visual puns and linguistic play are unique elements of Ms. Drucker's style. A richly suggestive work interweaving official history and individual memory, this book will permanently change your image of what follows that opening line, "In the beginning…."

This edition is based upon the Druckwerk original letterpress edition (1990). Printed offset on Warren's Lustro Dull at Soho Services. Bound in boards with dustjacket printed letterpress by Johanna Drucker.

Johanna Drucker

The History of the/my Worl(l)d

40 pages

11 1/4" x 8 1/2"

1995 Edition of 1000

asit through the sky / large and inordin-

orabilia just in the nick of time to fill

ories progressed precipitously.

Pairing was obsessional as writing was tracks traces
locked in drawers to which the key had been abandoned.

63. Holidays and ceremonies, solid
waste management and fossil fuels, and
burnt at both ends and the stake for the
sake of actual sacrifice but wasn't it
after all too late?

* * * ********************

* * * ******************

transformed into a
broadcast image. Now
was the time for some
serious war movies,
blinding the trenches
with serious explosives
while and entire genera-
tion was sold to the

61.

62. Captains of industry, exemplars of value, civic lunches
in the best tradition.

61. The red sun shone in the full fat belly of the whale making its
way against all odds.

Calling attention to the visual materiality of the text, this book attempts to halt linear reading, trapping the eye in a field of letters which make a complex object on the page. The writing refers continually to the visceral character of language, literalizing metaphors of tongue, breath and flesh. The work both embodies and discusses language as a physical form, one whose properties cannot be ignored by arriving at a disembodied content. The format of this work invokes a reference to the *Carmina figurata* of the Renaissance—works in which a sacred image was picked out in red letters against a field of black type so that a holy figure could be seen and meditated on in the process of reading. The technique is reversed here, with the red field of small type serving as a background in which large, black letters are arranged like figures on the red ground.

This edition is based upon the Druckwerk original letterpress edition (1989). Printed offset on Mohawk Superfine at Soho Services. Bound in boards by Jill Jevne with dustjacket printed letterpress by Johanna Drucker.

40 pages

8½" X 12¼"

Edition of 500 1996

Johanna Drucker

The Word Made Flesh

LWITHe
IKENE

turned to it

is heard. The throbbing impul

e

§

elf

Again
gain in the absence

of contradiction
truggle

to be real a
it

S elessly, taking the form
elf and inSist

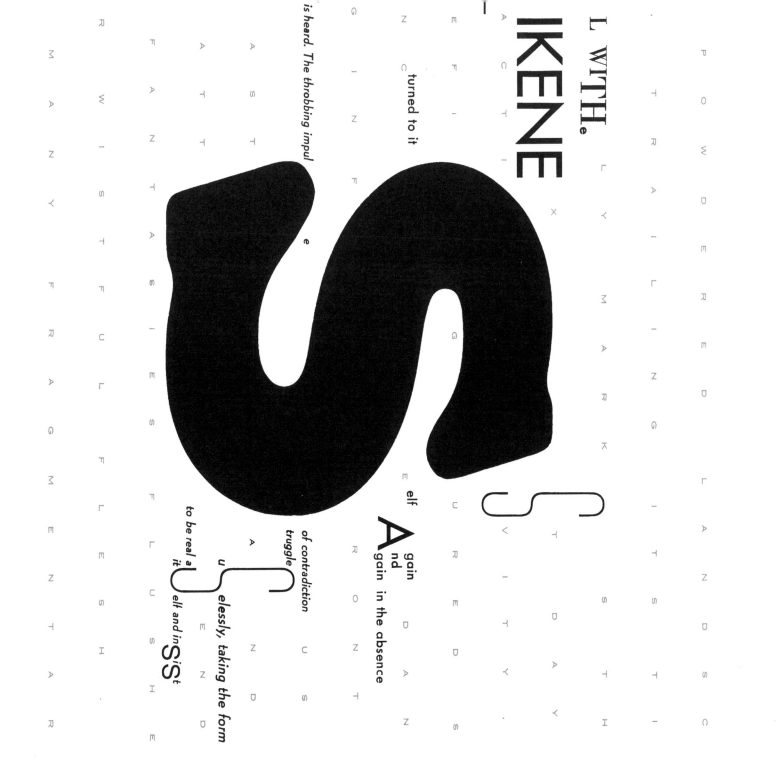

If It Rained Here

Joe Elliot & Julie Harrison

1997	Edition of 40
8³/₄" x 10³/₄"	10 *hors commerce*
24 pages	30 for sale

at cuts up what it sees cut up the eye

"Abstract in mode and collage-like in method, the book holds up a mirror—not to faithfully reflect what we see, but to fracture, crop and reassemble it. Thus, while parts of images come from and may hint at a variety of life-forms, these are not pictures of cells and embryos and water *per se*, but images of the elemental principles and forms behind these phenomena. In addition to alluding to preexisting forms, these images exist in their own right, side-by-side with their more natural brethren, so that each page is a new kind of creature, and the accompanying text is its voice. We see, then, that collage is not an invention of the modernists, but a natural process. Technology, which is usually considered an artificial and sophisticated method, can produce results that are true to the creative order. It seems, then, that human tools are not antithetical to the natural world, but part of it."

Julie Harrison and Joe Elliot, "Artists' Statement," *Leonardo*

This remarkable book is the result of a year-long collaboration between poet Joe Elliot and visual artist Julie Harrison. The

organic body-based images originate from video produced at the Experimental Television Center in upstate New York. Mr. Elliot's modular texts were excerpted or adapted from longer works and/or created in response to the images themselves.

Images captured from video and enhanced in Adobe Photoshop, collaged in QuarkXPress, then printed on an Epson Stylus Pro XL by Julie Harrison. Cover printed by Joe Elliot at Soho Letterpress. Bound in paper and cloth over boards by Daniel E. Kelm and staff at the Wide Awake Garage. All copies are signed by Julie Harrison and Joe Elliot.

Kenward Elmslie's way with words cuts a singular swath through a polymath variety of forms. Jukebox hitlet sung by Nat King Cole. Ahead-of-their-time lingo works: *The Champ*, poem, *City Junket*, play. Balloons for cartoons by Joe Brainard. Puréed anthropological tales of fantasy drinking establishments: *26 Bars*. Quirky surreal poetry mosaics (*Routine Disruptions*) that prompted Michael Silverblatt, host of NPR's "Book Worm," to finger Kenward Elmslie as **"Hands down, my favorite contemporary poet."** Mr. Elmslie's verbal swath includes *The Grass Harp* (Broadway cult-fave musical) plus *Cyberspace*, tech poem enhanced by Trevor Winkfield visuals. The wrap: *Nite Soil* introduces Kenward, poet of dense stanzas, to Elmslie, outed collagist of resonant icons in a smartly packaged collection of forty-one full-color postcards.

Printed offset. Postcards housed in a box. Twenty-six copies are lettered and signed by Kenward Elmslie with an original collage.

41 postcards

7" X 5"

2000 Edition of 3000

Kenward Elmslie

Nite Soil

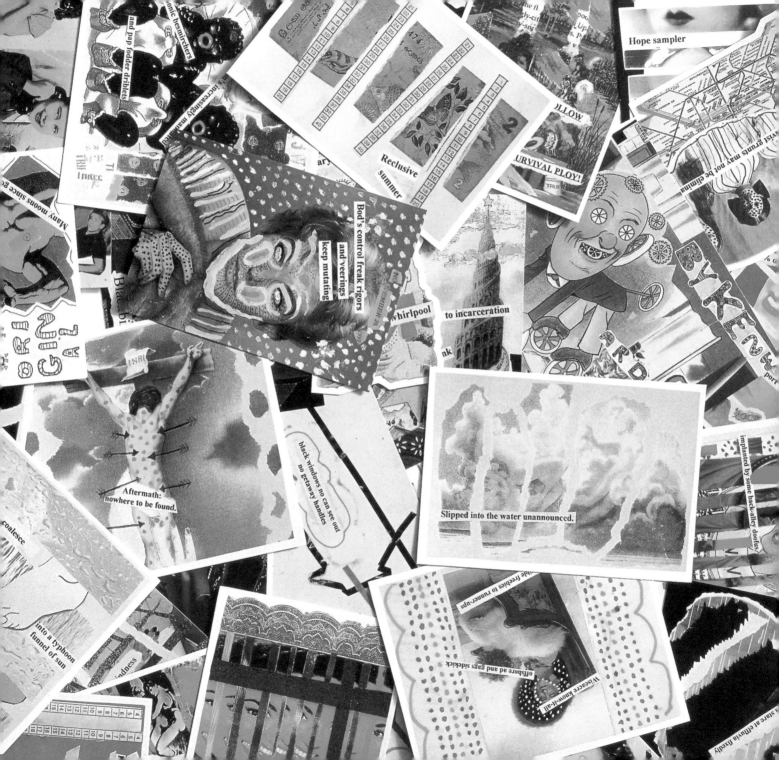

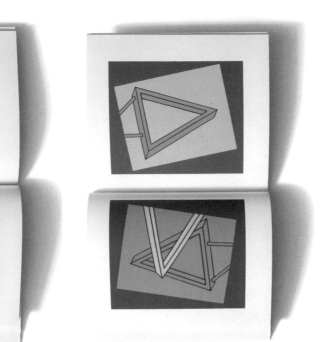

Cyberspace

Kenward Elmslie & Trevor Winkfield

2000 Edition of 3000

9½" x 8½"

48 pages

Cyberspace was created in a millennial visionary frenzy by two confirmed Luddites on the cusp of Y2K. **Time keeps the world from happening all at once, yet in *Cyberspace* we are yanked into the rabbit-hole and steam-rollered by a strange-yet-familiar cosmos of simultaneity: absurd, serious, musical, noisy, cartoony, colorful, witty, satirical, theatrical and deep. Trevor Winkfield's mid-maelstrom collages are illuminated by the torch of Kenward Elmslie's brilliant (if near pathological) reinvention of the English language. Together they ask, and possibly answer, the question, "why reinvent the wheel online via an all-pixel dream?"** *Cyberspace grounds us in an abundance of everything while it recreates our world in a daring act of imagination.*

Designed by Julie Harrison and Trevor Winkfield. Printed offset. Bound in paper wrappers with jacket. Twenty-six copies are signed by Kenward Elmslie and Mr. Winkfield.

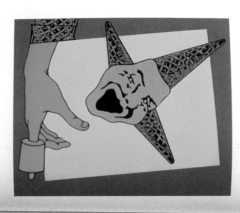

CYBERSPACE

Kenward Elmslie

&

Trevor Winkfield

Granary Books New York City 2000

In July of 1991, West Coast philosopher, ethno-botanist and psychedelic theoretician Terence McKenna visited Granary's exhibition of books and prints by Timothy C. Ely. His reading of Mr. Ely's work, remarkable for its empathy and eloquence, inspired the present collaboration. Mr. McKenna's text, typographically interpreted by Philip Gallo, is printed on, around and between Mr. Ely's painted and drawn images which Mr. Ely describes as "articulated glossolalia refracted from the writing."

"The restrained imagery and impressive typography allow space and guidance for the wandering eye. It is in this space between text and image that the magic of *Synesthesia* is found. Text and image merge, giving way to an experience that transcends the page....It is a rare and frightening experience, which has the potential of transforming the consciousness of the reader."

Barbara Tetenbaum, Bookways

Original painting and drawing by Timothy C. Ely. Text designed and printed letterpress on Rives BFK by Philip Gallo at The Hermetic Press. Bound in painted paper over boards with hinging structure by Daniel E. Kelm and staff at the Wide Awake Garage. A limnetic talisman is mounted to the front board. Housed in a cloth-covered clamshell box by Jill Jevne. All copies are signed by Mr. Ely and Terence McKenna.

55 for sale | 40 pages
20 hors commerce | 9½" x 7"
Edition of 75 | 1992

Timothy C. Ely & Terence McKenna

Synesthesia

unfinished.

Shamanism explores the attractor at the end of history through mushrooms and ayahuasca. Magic and Gnosticism believe the world has been l e f t.

Art should lead us out of history and into the mythic imagination.

Beyond history lies the design of the dream world. Art is called to anticipate and transform the future. Shamanism explores the transcendental attractor object at the end of history.

Mind is involved in a conquest of dimensions.

New World clustering.

Tropical clustering.

Ayahuasca as meme shift.

Metabolism is a fractal sculpted in time.

UNDERSTANDING

Language elves/whispers from the invisible. Flees on the back of God's gardener's dog. Are the simplest words, numbers? ※ ※ ※ Deepening ambiguity of the moment. Down loading into dream with an accurate image of nature. Our fate is to become our world.

Abstract Refuse presents a collection of English language words identified as **heteronyms: two or more words with the same spelling, different pronunciation, different meaning. The dual and sometimes triplicate existence of these words is combined with images to examine a structure for the mechanics of remembering and forgetting.** The clear and dense qualities of memory are constructed around the conditions formed by the single and paired heteronyms on every page. The book is structured to examine six stations of constituent and cultural memory: isolating the subject on a selected field; the mapped relations between remembered subjects; the mnemonic systems of cataloging and storage; the static interference of memories in conflict; the ground that re-members the dis-jointed forms; and the final station, recall. There are four conductors within each station who control the passages between analysis, intimacy, dream and ancestry.

Designed on a Power Macintosh 7100/66 with Aldus Freehand 4.0 and Adobe Photoshop 2.5, and printed with a Hewlett Packard 1200 C/PS on Rives Heavyweight Buff by Ed Epping. Bound in paper wrappers by Jill Jevne. All copies are signed by Mr. Epping.

34 pages

13" x 8"

Edition of 200 1995

Ed Epping

slough

Abstract Refuse

d
e
c
i
d
e

"*Secreted Contract* is the second book in a planned series of twenty-eight that will investigate two operations: an articulation of various mnemonic systems; and the incorporation of an English language word type (heteronyms) that, like memory, depend upon contextual constructs for their comprehension....[*Secreted Contract*] specifically includes an examination of heteronymic shapes and conditions (e.g., is the shape a circle tipped in a perspective or is it an elliptical form existing in a single plane? Is the couple engaged in a romantic, sexual embrace, or a scene of domestic violence?)...Trace is a form of template that blends the complexities of desire (as if) and situation (as is). It is this project of visually realizing how surface, trace, and glance might appear within the mnemonic structures that focuses my project."

Ed Epping

Designed on a Power Macintosh 7100/66 with Macromedia Freehand 8.0 and Adobe Photophop 4.0, and printed with a Hewlett Packard 1200 C/PS on Rives Heavyweight White by Ed Epping. Bound in paper wrappers by Jill Jevne. All copies are signed by Mr. Epping.

34 pages

11" x 6 3/4"

1998 Edition of 60

Ed Epping

Secreted Contract

reason

used

raver

live

The hum was co
in her credenza
even leaving. W
they have to let
take your duste
your foot down.
in your own wo
you'll be back i
onto rotary cylir
don all thoughts
of pattern books
thing on. What's

If the twentieth century was *the* century of artists' books then *Dig & Delve* is a perfect final act as it embraces the contra-dictions that characterize the beginnings and endings of the nineteen hundreds. *Dig & Delve* is a postmodern illustrated book; it tropes on the genre of the much maligned *livre d'artiste*, playfully dancing on the tightrope between pre-Raphaelite sensibility and radical artifice. Ultimately a happy work, *Dig & Delve* is optimistic, antediluvian and generous; a perfect passport to the next (or present depending upon how you count) millennium.

"At a time when glib appropriations of popular culture permeate almost every facet of contemporary art, [Trevor] Winkfield transforms a pop-inflected imagery into something personal and rooted….His work looks nothing like the major art we've come to expect from the standard surveys of late-twentieth-century culture."

Mario Naves, *The New York Observer*

Typeset by Ruth Lingen and Barbara Henry. Printed letterpress on Somerset by Ms. Lingen at Pooté Press. Bound in cloth over boards by Judith Ivry. All copies are signed by Larry Fagin and Trevor Winkfield.

Larry Fagin & Trevor Winkfield

18 pages	50 for sale
8½" x 10¼"	17 *hors commerce*
1999	Edition of 67

Dig & Delve

Then we noticed the dent
e chief split the scene, not
through the opening where
with us now. The page will
ot speed up when you put
cat, you have to stop living
of those sneak attacks and
tory, bolting curved plates
t that's the way it is. Aban-
id the grand piano. Beware
nyone you don't have some-
broken melody you can play?

No strict pattern holds. We had to let go of rule of thumb. I can't explain but you understand. A need to internalize the chief's words, creating animated mental models of the chief and his sayings. Mix our blood with the Indians. Then he sets out and we fall in behind him. The little crust of blood appeared in many places at once. Molecules stood on their heads, constituting a scene: the view that life was something happening to us. Ink-accepting. Its only claim to be was that it was happening without us, a hair wound around a nail. That's enough truth. When the meaning becomes clear, I'll be able to

Away

Ed Friedman & Robert Kushner

Edition of 2000 ca. 54 pages ca. 50

"Something about the descriptive and imagistic nature of *Away* made me think of the artist/poet books designed by Léger, Matisse, Kandinsky and others....Steve [Clay] and I discussed some of the artists with whom I'd previously collaborated. We agreed to approach Robert Kushner as a collaborator. Though Bob and I had collaborated a lot during the 1970s and early 1980s, we hadn't in awhile, and I thought it would be great to work together again.

"Bob read *Away* a lot. Fairly early on, he decided that it didn't make sense to illustrate the text. He kept telling me that he liked how 'slippery' the writing was. I think what he meant was that individual pieces have the feeling of narrative—a center or location with points of interest— but the specifics shift around and fly off in many different directions. Illustration, even if possible, would tend to lock down meanings that were better left transient.

"What Bob has done is create a number of images which correspond to some of *Away*'s recurring imagery. Stars, water, foliage, etc. are printed around and beneath the text in varying combinations and in different colors. With the writing, the printed images create a coherent and shifting visual milieu."

Ed Friedman

Printed letterpress by Ruth Lingen at Pooté Press. Bound in cloth over boards by Judith Ivry. Signed by Ed Friedman and Robert Kushner.

Egress

To enter the world of animals, we stop eating them. A hundred women squat and spread piles of dried corn around the plaza. Along every trail men file into town carrying children on their shoulders. We've had our last bipedal gallop in the highlands, I'm afraid, because once we're "with the creatures" we'll be romping through sky on four legs. Much in the way of motion will be instinctual. We'll smell oncoming rain. Look, a walking fish with a pipe in its toothy lips! It's Uncle Herb, more himself than ever! Is it possible that so many people can find happiness as parrots and quail? Look at us!

We're about to have sex as llamas! And it's love!

Soliloquy

Kenneth Goldsmith

Edition of 2001
ca. 1500
ca. 9" x 6"
ca. 100 pages

"If every word spoken in New York City daily were somehow to materialize as a snowflake, each day there would be a blizzard."
Kenneth Goldsmith

Soliloquy, a written record of every word spoken by artist, web designer and DJ Kenneth Goldsmith during one week, debuted as a text installation in 1997. Presenting all of one man's words in a continuous, abstract stream, the work inspired self-examination by both artist and viewers. In this book version, language is concrete as well as arranged. The collection of words is divided into seven "acts" through which the structure and sequence of Mr. Goldsmith's days becomes evident.

"Confronted with the clutter of 'real' speech (not to mention its content, which might prove more embarrassing than its stammers and mumbles), we realize that we all sound a bit like George Bush. This originating concept may be simple, but the end result is a complex provocation on language and visuality, documentary, autobiography, and the elusive relation between an individual's speech and the linguistic patterns of a particular social milieu....By choosing to cast *Soliloquy* as both installation and book, Goldsmith is drawing attention to the fact that reading and looking are not equivalent activities."
Gordon Tipper, *zingmagazine*

Printed offset. Bound in paper wrappers.

Good morning, how ya doin'? Yep. Wait a second, I have my ticket. O.K. There you go. Thanks. See you soon. Oh oh oh, I thought you said "Have a good weekend..." "Oh, O.K. Have a good week. See you later. How you doin'? Alright, alright. Two, please. You don't want to save that for four or is it OK.? Do you have any newspapers lying around? I'll just have a coffee to start. Thanks, O.K., babe. O.K. How ya doin'? Uh huh. Regular. I'll take regular this time. Did you go all the way back to the gallery? You're sweating. That's good—it's good for you. Oh, thanks. Yeah, of course. Everybody knows that guy. He's sort of...sort of famous. I saw a bunch of these actually on the racks. Yeah, I don't know, I was told out and in the world, which is pretty neat. That's cool and I like that. Very Cool. We've gotta get a poster. I don't know, I don't know. I was told by people there was a poster there. Yeah, I know. That's why you can't take publicity too seriously. Yeah, maybe other people do—they love publicity. So, have you been sleeping? No, don't worry—your life will change. Be assured, your life will change. Sure. Sure. So I'm told. Yeah. Oh, yeah. Oh John, do you know what you want? I do. I'd like the uh, pancakes, uh short sounds good. A little more coffee and some water. Has Karin been out of the house? That's right you guys had an opening. Well, I heard it last Sunday. It's really nice that all the artists came over. Yeah. I thought that was really cool. I mean, we all came over at the same time. I thought that was very hip. Good move. That means you only have to tell the stories once. Bitter? You want some milk? How was your opening? This is the paintings. And what is the artist's name? And where is she from? Regular. Thanks. Worse than me? Isro. Sure. Did you see that article on Mason Reese in the paper? Wasn't that depressing? Ohhh. Yeah. I mean it's also like the, I mean, it's also like the Danny Partridge, what's his name? The Danny Partridge story? Yeah, but it was really sad. But the best one was that little retarded black kid. No, no. The one from, you know, the one from...he was adopted into that family—the white. He's really short and he went off to rob dry cleaners. Right, OK, right. What was the name of that show. Anyways...Yeah, I mean, it was on in the early 80s and I wasn't watching TV, then. Yeah. Willis. Right. Right. And I can't remember the name, either onstage or off of the short guy. Gary Coleman and the girl was Kitten? But she robbed a store. At any rate, Eddie Van Halen? Remember Valerie Bertinelli like when she was like on T.V. when we were kids and when she first came on T.V. I had a real crush on her? Something like that. Yeah, she was very adorable. You know, I think the latest incarnation is

Rejected from Mars

Ric Haynes

1995	Edition of 30
14" x 10"	10 hors commerce
56 pages	20 for sale

Murky, raw, cartoony, fierce, intense, swampy, dark, labyrinthine: this work is a sort of travelogue through a tortured but visionary psyche which ultimately resolves into a hard earned emotional stasis, though one manifestly maintained a day at a time.

"I made *Rejected From Mars* by combining images and words that tie together ongoing experiences. Working as an expressive arts therapist, I was hearing incredible stories from adult schizophrenics. I wrote a fictional re-construction of fragments of different conversations. The drawings were in part illustrations of the process of the words that also became images. I committed myself to make a book in linocut, and hand colored fifty-eight pages, thirty times. The process was very similar to book production in the middle ages. Looking back, I would say that the contents are filled with ongoing marginality of life, contained in book form."

Ric Haynes

Linocuts by Ric Haynes printed by Philip Gallo at The Hermetic Press then handpainted by Mr. Haynes. Bound in painted paper and cloth over boards and housed in a slipcase by Jill Jevne. Signed by Ric Haynes.

"Lyn Hejinian's work increasingly explores poetry's relation to knowledge….But rather than abstract frameworks, one finds in [A Border Comedy, a serial poem in fifteen 'books'] coyotes, geese, didactic asides, horses, philosophical anecdotes, hawks, intercourse, wasps, Russian Formalist literary terms, goats, pigs, ravens, and a great deal of urinating. It is through this particularity that Hejinian invents a poetic pedagogy at home with its forgiveness to itself, poised both to topple and attain intellectual authority, happily open to its lack of totalizing system….Situating her project more broadly within intellectual history, she writes: 'Digressing in a didactic tale will teach one to digress.' And digression, in all of its entertaining modes—the anecdote, the interpolated comment, the sudden shift of attention—is the displaced center of A Border Comedy….One of the interesting oddnesses of the book, one that forces us to catch our breath and occasionally to huff, is that quasi-transcendental or a priori insights (often linked to continental philosophy) find their way skillfully and unpredictably into what is otherwise a radically nominalistic, context-dependent intellectual setting."

Lytle Shaw

Printed offset. Bound in paper wrappers. Twenty six copies signed by Lyn Hejinian.

Edition of	2001
ca. 1500	ca. 9" x 6"
	ca. 200 pages

Lyn Hejinian

A Border Comedy

ook One

ll the clouds can feel

we just use some im

ome instigation

that ambition?

hen let the rains desc

he imagination is use

free of prejudice

The Lake

Lyn Hejinian & Emilie Clark

Edition of — 2001
ca. 1500 — ca. 10" x 10"
ca. 24 pages

"In October of 1999, we spent a week together on Lake Wentworth in New Hampshire. Our intention was to begin work on a collaboration that would require us to work in each other's medium as well are our own. We wanted to attempt a work that was site-specific and also time-specific. Our previous collaboration, *The Traveler and the Hill and the Hill* [Granary Books, 1998] had evolved over the course of several years, and for most of that time we had worked on our respective parts separately, and this time we wanted to explore the possibilities and problems of a collaboration in real time. Indeed, 'exploration' was to be one of the themes of the work, and in retrospect the work can be seen as a study of an ecosystem, in which the lake figures both as a literal and a metaphorical landscape. Language and visual imagery were the ecological elements in the system of the work, as the various material forms above, around, and below the lake's surface were in that of the site. We were interested in the interrelationships, simultaneities, and the extents of layers; we were thinking about complex emotional and aesthetic terrains along with the literal one we were investigating. We imagined the lake as a site and described such a site as being constituted by all possible responses to it. We worked from early morning to late at night, taking breaks to walk along the lakeshore or go out into the lake in a kayak, photographing along the way (the rolls of film were developed at a one-hour photo processing shop in the nearest town). At the end of the week we found we had a sequence of pages that we felt together comprised a work. Naturally, we called it *The Lake*."

Lyn Hejinian and Emilie Clark

Printed offset. Bound in paper wrappers. Twenty-six copies are lettered and signed by Lyn Hejinian and Emilie Clark.

an overlapping
differs from a shared
the site is part aftermath
increment a
lake can be seen
as a strong inclination a
suspended
barrier or a
sunken measure
emotion is meant with sensation
shapes
where
lake
doesn't
desist

Lyn Hejinian & Emilie Clark

The Traveler and the Hill and the Hill

There was once a rich farmer's la
he was going out wooing

me to the door, touched it with
he flower, and the door flew open

he horses in the stable
stood up and shook
themselves, the hounds
leapt about and wagged
their tails, the flies on
the walls began to crawl
again, the doves on the
roof lifted their heads
from under their wings
and looked around,
and then they flew into
the fields

1998
11 1/2 " x 10"
70 pages

Edition of 61
16 *hors commerce*
45 for sale

The Traveler and the Hill and the Hill is a collaboration between poet Lyn Hejinian and artist Emilie Clark. In the first half of the book, Ms. Clark's richly layered monoprints respond to Ms. Hejinian's aphoristic poems; in the second half, Ms. Hejinian comments on Ms. Clark. **The book presents a series of fairy tales gone awry—gone from the secure world of familiar knowledge and avuncular authority imparted to children into a hilarious, dark and dramatic space in which thinking happens in the seams between sentences.** While Ms. Hejinian's poems investigate the social logic that binds short, illustrative moral narratives, Ms. Clark's monoprints invent a space for this investigation in which rich colors, widely various drawing, printing and transfer images behave almost as characters.

Monoprints by Emilie Clark. Text designed by Lyn Hejinian and Emilie Clark. Printed letterpress on Rives BFK by Philip Gallo at The Hermetic Press. Bound in cloth over boards and housed in a cloth-covered slipcase by Judith Ivry. Cover fabric printed by Ruth Lingen. Signed by Lyn Hejinian and Emilie Clark.

Bed Hangings

Susan Howe & Susan Bee

Edition of 2001
ca. 1500 ca. 10" x 7"
ca. 48 pages

In *Bed Hangings*, poet Susan Howe and artist Susan Bee collaborate for the first time. This series of poems explores the themes of colonial America and its decorative arts, religion and Puritanism through a visual and verbal investigation of the metaphysics of beds, curtains and hangings. The poems and pictures play off against each other in a humorous, mystical and sometimes mischievous manner.

"I am an insomniac who goes to bed in a closet.

'AWAKE, a., not sleeping; in a state of vigilance or action.'
'AWAKENING, n. A revival of religion, or more general attention to religion than usual.' Although these are Noah Webster's definitions, out of his writing speaks Calvin. For Calvin the Bible contains two kinds of knowledge—ecstatic union and law. In *An American Dictionary of the English Language* a curtain is a cloth hanging used in theatres to conceal the stage from the spectators, while an itinerant is someone who travels from place to place and is unsettled; particularly a preacher....When Europe enters the space of its margin, the 'Kingdom of God in America' receives European memory into itself. In thin places bedsteads confront their own edges....Field beds have canopies at the top resembling tents. One Sunday afternoon in the gift shop at Hartford's Wadsworth Atheneum...my attention came to rest on a pedestrian gray paperback. *Bed-Hangings: A Treatise on Fabrics and Styles in the Curtaining of Beds, 1650-1850* with its drab cover illustration...struck me as vividly apropos. I wondered who tipped over the vase of flowers to the left of the bed in the painted East Chamber? Did the spilled flowers suggest a stray sense of comedy or inspired simplicity?"

Susan Howe, from the Epilogue

Printed offset. Bound in paper wrappers. Twenty-six copies are signed by Susan Howe and Susan Bee.

Nor hemp to pleasure pillow
Nor clay scorn to cover as if
sphere of the pent lake hold
Infold me bird and briar you
fathom we cannot to another
declare characters in written
summit granite cramp marble
Simple except a blank that it

Providing in-depth readings and analysis of many individual artists' books, *The Cutting Edge of Reading* establishes a useful international twentieth century overview of the genre. This splendid volume expands upon and extends the work initiated by Renée Riese Hubert in *Surrealism and the Book* (University of California Press, 1987) by focusing acute critical attention on recent and contemporary artists' books.

In *The Cutting Edge of Reading*, Judd D. and Renée Riese Hubert develop a discourse which starts where discussion of the *livre d'artiste* leaves off. The study begins with a chapter on "Transitions," which examines the work of Pierre Alechinsky and Paolo Boni, among others, before developing and discussing, through close readings, such themes as "Visual Deviants and Typographical Departures," "Various Ways of Frustrating our Reading Habits," "Altering Books—The Cutting Edge of Editing," "Variations on the Accordion," "The Book, The Museum, and Public Art," "Satire," "Concretions of Memory," "Narratives and Verbal Manipulations," "Metamorphosis of Childish Games" and "Fashioners of Books." *The Cutting Edge of Reading* stands as a useful compliment to Johanna Drucker's *The Century of Artists' Books* (Granary Books, 1995) and is a necessary reference tool for scholars, critics, collectors and librarians.

"The Cutting Edge of Reading offers perceptive insights into a representative selection of recent publications. In their careful analysis, the Huberts demonstrate how artists' books lay bare the artfulness and the artificiality of the book as a work of art, not to denigrate the cultural conventions shaping it…but drawing attention to a new hierarchy, one in which the book is no longer merely read but experienced as an aesthetic phenomenon."

Martin Heusser, *Interactions*

Designed by Philip Gallo. Illustrated with color and black & white halftones. Printed offset. Bound in cloth over boards.

280 pages

10½" x 8½"

1999 Edition of 1500

Renée Riese Hubert & Judd D. Hubert

Artists' Books

The Cutting Edge of Reading:

64.
Joan Lyons.
The Gynecologist.
Altered page from
Casseria.
1981.

notably Leonardo and Vesalius. Lyons' illustrations come from documents beginning at the end of the 15th century. They mostly refer to the uterus, which here provides stylized and even decorative images. We view female organs alternatively from the inside and the outside, as part of a whole body or in isolation. On the left, the artist usually presents a female figure changing her position and gestures in each plate. We invariably see the body of the woman as wide open. (Fig. 64) On the right side, decorative patterns consisting of organ parts, both female and male, as well as the tools and charts involved in diagnosis, treatment, and cure, surround the framed unpretentious letterpress. We would assume that photography, x-rays, lasers, and ultrasound, sure signs of medical progress, would entail the disappearance of such primitive drawings. But Lyons has chosen to convey a far different message: a lack of real progress, for women

still remain in bondage and patriarchal methods prevail as before. Old textbooks abounded in phallic representations of the uterus as exemplified in the horned uterus displayed on the cover.

The dedication to a hopefully enterprising daughter of Eve, that biblical victim who lusted in vain for knowledge, functions as a caption for a seated woman figure exemplifying the paradoxical nature of male attitudes toward women. Although the engraver has scientifically displayed her numbered inner organs, he has by no means neglected to represent her feminine charms. Her bent knees harmonize with the upward gestures of her arms and the curly hair decoratively descending on her shoulder. Moreover, one of the wide open wombs belongs to a headless, legless and armless excavated marble statue and another to the classical representation of a goddess. More elegant even than Eve's daughter, she wears a drape whose pleats respond to the folds made by the flap of her open body. This anatomical engraving with its numbered organs exposed poses in a discreet landscape typical of Renaissance backgrounds.

In order to make the graphic project a full-fledged accompaniment to the afterword, Lyons represents two famous surgeons getting ready for an operation. Learned men surround an anesthetized, stretched out and open-bellied female. Confronting on the opposite page intimidating surgical instruments, the final plate comes from an advertisement in triplicate for *Great Moments in Medicine*, 1945. The scene seems to belong to a stage rather than an amphitheater. Old anatomical treatises and artists' books show, but for quite different reasons, the same penchant for theatricality.

"All of [Edmond] Jabès's books explore the double wound of consciousness, our being set apart from the rest of creation in the glorious and murderous species of humankind, and set apart from our fellow humans as individuals....His work explores the nature of the book and word, of man defining himself through the word against all that challenges him: death, silence, the void, the infinite—or God, our symbol for all of these."

Rosmarie Waldrop, "When Silence Speaks"

Desire for a Beginning Dread of One Single End, translated by Rosmarie Waldrop, is a series of short aphoristic assertions permeated with a sense of melancholy and mortality. It is among the last substantial works of Jabès to be published in English. Ed Epping designed and treated the work with subtle digital images.

"I first read *The Book of Questions* twenty years ago, and my life was permanently changed by it. I can no longer think about the possibilities of literature without thinking of the example of Edmond Jabès. He is one of the great spirits of our time, a torch in the darkness."

Paul Auster

Printed offset. Ca. 1958 copies bound in paper wrappers; ca. 42 copies, which include special inserts, bound in boards (of which 12 are *hors commerce*).

1988 for sale

12 *hors commerce*	56 pages	
ca. 2000	7" x 4¹/₄"	
Edition of	2000	

Edmond Jabès & Ed Epping

Desire for a Beginning Dread of One Single End

wound

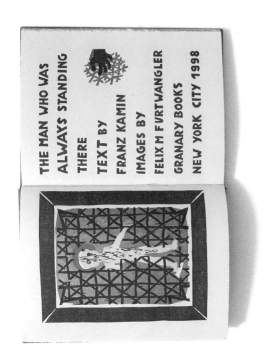

"Franz Kamin is a uniquely multidimensional artist and thinker. A musical composer, poet and author of prose narratives and performance works combining several media, he playfully and seriously incorporates in much of his work concepts and procedures derived from such fields as topology and linguistics. But withal he's a deeply emotional romantic artist, much of whose work arises from his personal relationships. There's no one like him."

Jackson Mac Low

"Felix Furtwängler's art includes representational elements, free in the way of drawing, competent and spontaneous, and they use the graphic medium masterly and experimentally....[His] woodcuts, rich of contrasts, create paths and borders, they incorporate signals and letters...closely connected to writing."

Joachim Kruse

Text for *The Man Who Was Always Standing There* is excerpted from a longer work by Mr. Kamin, *The Theory of Angels*. The words are literally built into Felix Furtwängler's woodcuts to

57 pages
40 for sale

1998
13" x 9¾"
20 hors commerce

Edition of 60

Franz Kamin & Felix Furtwängler

The Man Who Was Always Standing There

become part of the image. The many-colored woodcuts are of a powerful, expressionistic style. Mr. Furtwängler also designed the patterns for the book's covers and endpapers.

Woodcuts by Felix Furtwängler printed by Ruth Lingen on simili japon paper hand-painted by Mr. Furtwängler. Casebound in printed cloth over boards and housed in a printed cloth-covered slipcase by Barbara Mauriello. Five copies are sets of unbound sheets. All copies signed by Franz Kamin and Felix Furtwängler.

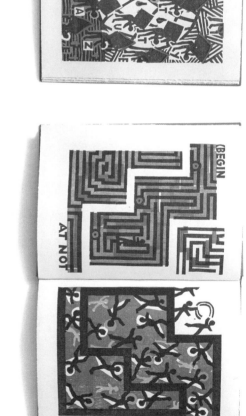

Notes on the Body

Shelagh Keeley

"[Shelagh] Keeley continues her very personal exploration of the body in this sumptuous book, more drawn than printed, fusing a sensuous whole from such contrasts as East and West, past and present, scientific and perceived. Most often she does this by juxtaposing xerox transfers—she uses a wax process—of anatomical diagrams from her collection with her own drawings of the same body parts in gouache, ink, charcoal, wax, or pigment. These drawings—in an existential palette of browns, reds, yellows, and blacks—fill each page much like her drawings on walls extend the space of framed images in her installations. **'In my installations,'** she has written, **'I am concerned with the recovery of space through gesture. There is an awareness of the body in my work process and my installations become psychological extensions of the body. Concerns in my work are: gesture of the body, gestures of the site, an architecture of emotion, the body and architecture.'** She conveys those concerns within the space of this beautiful book."

Print Collector's Newsletter

Photographic transfers with original drawings in pencil, pigment, pigment, gouache and wax by Shelagh Keeley. Title page and colophon printed letterpress on Rives BFK Gray by Philip Gallo at The Hermetic Press. Bound in boards by Daniel E. Kelm at the Wide Awake Garage. Housed in a cloth-covered clamshell box by Jill Jevne. Signed by Shelagh Keeley.

1991 Edition of 17

15" x 11" 7 hors commerce

44 pages 10 for sale

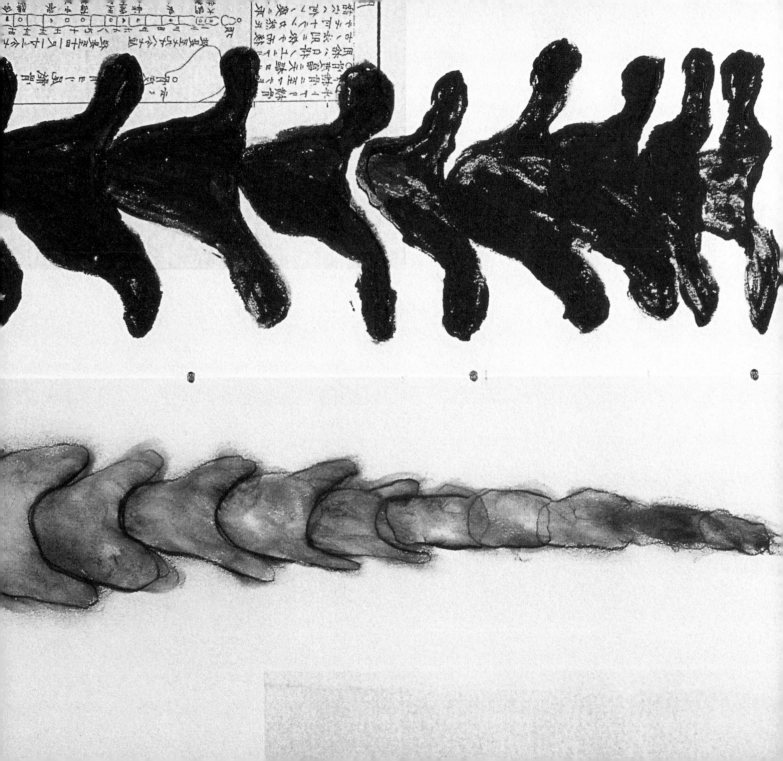

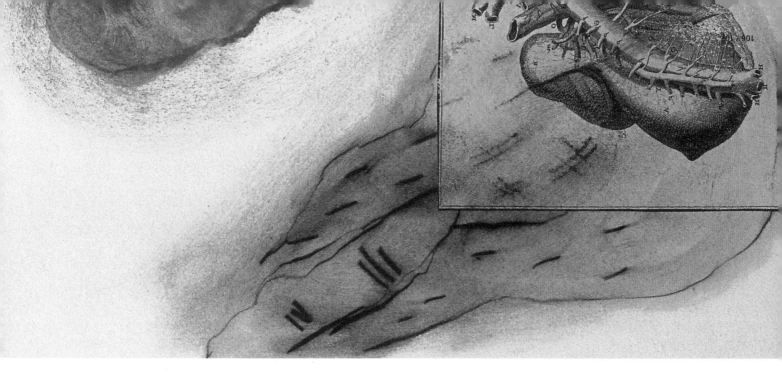

A Space for Breathing

Shelagh Keeley

Edition of 22 1992
8 hors commerce 15" x 11"
14 for sale 50 pages

A Space for Breathing extends and expands the vocabulary of images initiated in *Notes on the Body* (Granary Books, 1991). Shelagh Keeley employs photographic transfers and original drawings in an exploration of the body's organs and limbs—images reminiscent of **"the iconography of ex voto offerings and retabla charms. *A Space for Breathing* is more abstract, more closely integrating the themes of gesture and space, the body and architecture....In an age in which the body is the site and battleground of so many issues, debates, policies and struggles, Keeley's work is meditative and generative, emphasizing a celebration of the material physicality of being, the pleasures of sensation and bodily experience."**

Johanna Drucker

Photographic transfers with original drawings in pigment, gouache and wax by Shelagh Keeley. Title and colophon pages printed letterpress on Rives BFK Gray by Philip Gallo at The Hermetic Press. Bound by Daniel E. Kelm at the Wide Awake Garage. Housed in a box by Jill Jevne. Signed by Shelagh Keeley.

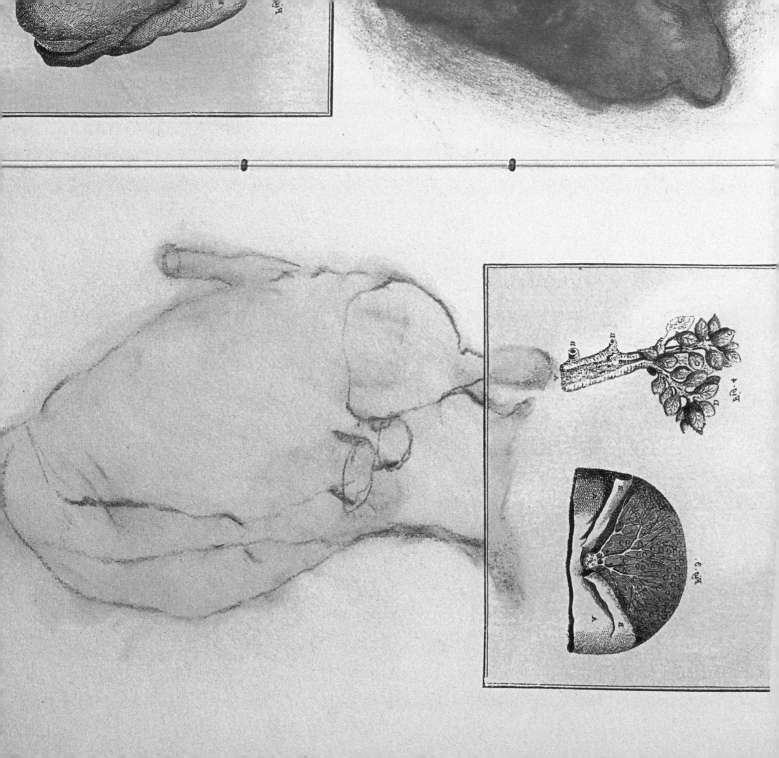

Artists Books: A Critical Survey of the Literature contains five essays which chart the ongoing critical debates surrounding artists books. "Stefan Klima's text is an invaluable resource for anyone wishing to explore the development of critical debates on artists books. Beginning with documentation from the late 1960s, Klima carefully charts the discussion of several central issues: the identity of artists books, their disputed origins, and their current status. His summary of debates is handled with the evenhandedness of an outsider; he maps the sometimes fractious and frequently contentious dialogues among interested parties with scrupulous care. **His bibliography is a thoroughly useful guide to the critical and historical texts. It has the advantage of being well focused on the topic and thus serves as an essential point of departure for any student, librarian, critic, or collector interested in pursuing the literature on artists books. A welcome addition to a steadily growing body of works in the field."**

Johanna Drucker

"Artists Books: A Critical Survey of the Literature deftly assembles the main points of the debate about these works that has stretched over several decades. Viewing the entire corpus of critical writings, Klima's book draws attention to important gaps in the discussion of artists' books....Klima's book should provide an impetus to gain a clearer understanding of these works and their relation to both the contemporary art world and the traditional book arts."

AB Bookman's Weekly

Designed by Stefan Klima with additional typographic work by Philip Gallo. Cover device based on an illustration by Clive Phillpot. Printed offset. Bound in paper wrappers.

Edition of 1500

1998

8 3/4" x 5 1/4"

104 pages

Stefan Klima

Artists Books:
A Critical Survey of the Literature

ewards. "The ... misunderstanding is the basis
[i]sm —that books would allow artists to liberate
[fr]om galleries and art critics ... what for? To fall
[a]s of publishers and book critics!"[72]
[,] early in the debate, expressed the same senti-
[c]ognized a major hurdle, expressed "books are capable
[ex]ploitation that a Pollock canvas is subject to.
[]to produce the books and someone has to
[m]. A gallery and bookstore perform the same
[Phi]llpot uttered the same cry, in a conference
[]would anyone want to subvert dealers?
[d]e is as commercial as the gallery world ...
[]just another idea about artists' books invented

the issue of alternatives to the establishment
[t]he National Endowment for the Arts granted
[]s for the creation of artists books. If dissemi-
[]ll a problem, artists could now compete for
[]port the production of books. A government
[] giving recognition to a discipline of work;
[]tablishment was not only giving recognition;
[]ing the few at the expense of the many.[75]

[ió]n, "Bookworks Revisited." Second Thoughts. Amsterdam:
[]s, 1980: 64.
[]unin, "Introduction." The Dumb Ox 4 (Spring 1977): 3.
[] David Trend, "At the Margins: Artists' Books in the
13, no. 1 / 2 (Summer 1985): 3.
[]enny, "On Artists' Book Publishing." Afterimage 12, no. 8

READING THE BOOK

"In the new art," wrote Ulises Carrión, "every book require[s] a different reading."[1] This new art will create "specific read[ing] conditions."[2] Carrión was writing about a new kind of activity, insisting that for a complete and accurate reading of the new kind of book it was vital to understand the book as "a structure, identifying its elements and understanding their function."[3]

These new kinds of books were to instill in readers a new consciousness about books which Carrión felt had been neglected. This idea was cherished by many. However, in Carrión's case, his message was intended for a literary audience but it migrated to visual artists and bookmakers.

Carrión wanted readers to be aware of the complete form and structure of the book, a marriage of the external form and an internal text. Drucker described this as a self-consciousness about the book, "which interrogates the conceptual or material form of a book as part of its intention, thematic interests, or production activities."[4]

1. Ulises Carrión, Second Thoughts. Amsterdam: Void Distribution, 1980: 20.
2. Ibid.: 21.
3. Ibid.: 20.
4. Johanna Drucker, The Century of Artists' Books. New York: Granary Books, 1995: 3.

Footnotes:
collage journal 30 years

Alison Knowles

"The work that Alison Knowles has given here is a personal *kunstkammer*—a treasure house of words and images that underlie an art that she has made and taken with her on a journey through and over many worlds. That journey now covers a span of thirty years and more. As such it links with a history of what has been—in the time that she and we share—an adventure in making and extending art as it was understood before her."

Jerome Rothenberg, from the Pre-face

"Once upon a time Jim Tenney and I went walking in the woods. We came to a clearing and there under a tree was an arrangement of toy locomotives in the middle of nowhere. Pausing we mused where are they going, where have they been?"

Alison Knowles

A collection of collage pages made from thirty years of small, red travel books pasted up and redrawn, but in no defined order. The setting migrates from Japan to Cologne and back always to New York City. Ideas jotted down and friends' conversations overheard are a loosely woven context for these delicate pencil drawings.

Designed by Julie Harrison. Cover by Sara Seagull. Published to coincide with Alison Knowles's exhibiton (also titled "Footnotes") at Emily Harvey Gallery. Printed offset. Bound in paper wrappers. Twenty-six lettered copies an six numbered (*hors commerce*) are specially bound by Judith Ivry and signed by Ms. Knowles with an original collage.

Edition of 2000
10" x 7" 1000
248 pages

Toni
π

Based on the eponymous video/book installation made by the artist team Nora Ligorano and Marshall Reese, this book contains a printed collage of video stills, newspapers, art history books and magazines, as well as handpainting by the artists. **"The current tension of the book reflects the present tense of electronic media continuing to come into being. This is not a contrast between the space of the real and the space of the virtual, but between two modes of imaginative life for thought, language, and the eye, each competing to determine the relations of history, language, and thought.** As the page was once written so the monitor redraws itself. The new temporal logic of history still remains to be seen. Here the transcript is watched and watching its viewers who struggle to preserve some illusion of participation in the process. Where will the marginalia appear, the annotations of the reader, if the history which writes itself in the future is always on the inside of a glass surface which resists inscription? Whose idea will have been a moment on the screen and whose impressed on the receptive pages of a more tangible memory when both are proved to be material traces of the elusive, immaterial seeming, process of thought?"

Johanna Drucker, from *The Corona Palimpsest: Present Tensions of the Book* exhibition booklet for "Corona Palimpsest" video/book installation by Ligorano/Reese

Collages printed letterpress on 120 gm Arches text laid by Joe Elliot and Anne Noonan at Soho Letterpress. Stills printed offset on Yu-jade. Handpainted by Ligorano/Reese using stencils and paste paper methods. Bound in cloth over boards by Daniel E. Kelm and staff at the Wide Awake Garage. Signed by Ligorano/Reese.

1996	Edition of 40
12 1⁄2" x 10"	10 hors commerce
42 pages	30 for sale

Ligorano / Reese

The Corona Palimpsest

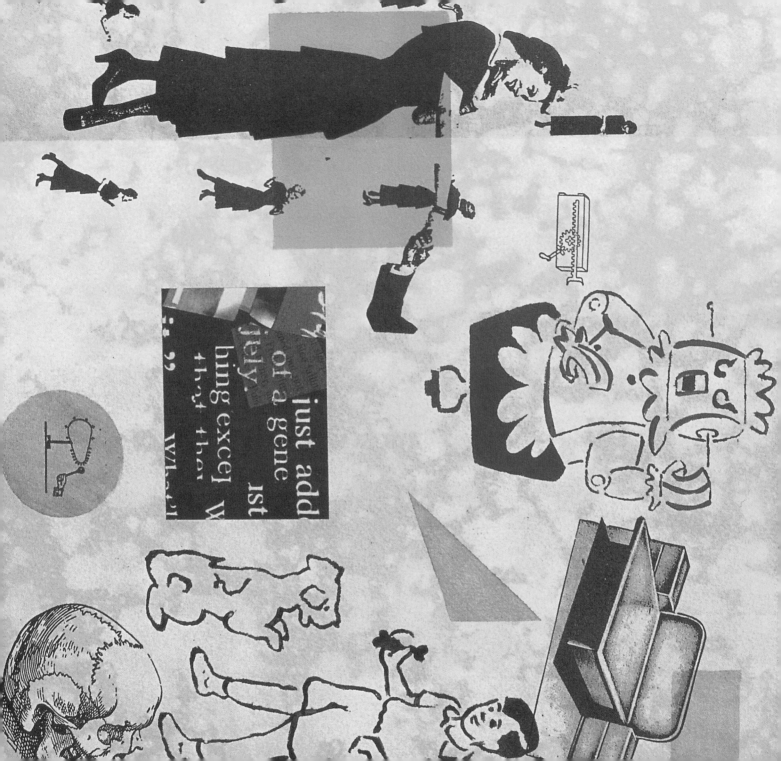

"In Kimberly Lyons's poetry of perception, it is the unmoving objects that do the striking when there's a collision—the floor hits the spoon, the small black pan hits the 'big kosher salt' that's falling into it. The resulting energy sends words zigzagging and meaning flashing like lightning. This makes sense, since these poems take place in the thunderstorm where the cold sciences of optics and physics meet psychology—object relations—in all its warm folds of association and sublimation. In the annals of the irreal, Giorgio de Chirico's monumental paintings and Joseph Ceravolo's early poems also suffuse this cold light with heartbeat. What's absent in the book is Absence, for although the affect of these poems seems to be low-key, it's really just the tense relaxation of a poet of the ecstatic magic of paying attention. The depths of all the apparently empty spaces are filled: with music, with light."

Jordan Davis

"[Lyons's] work, for all of the influences it summons, is truly a rallying cry for independence from the lineages of the past, for the freedom to follow 'paths internal.' *Abracadabra* marks a defining moment, a real opening, a step onwards."

Lewis Warsh, *Poetry Project Newsletter*

Designed by Emily Y. Ho. Cover image by Tony Fitzpatrick. Printed offset. Bound in paper wrappers.

104 pages
7½" x 5"
2000 Edition of 1000

Kimberly Lyons

Abracadabra

Abracadabra

We watch together
black collide with white.
This is not the night
falling around snow

or a mailbox swallowing
our letter
frozen dark air around ice cubes
the white sink cups
wet black pantyhose
like a lake seen
from the
small window of a train.

The window of a face
on film
big kosher salt in a small black pan.

When artist Ed Epping received Kimberly Lyons's thirty-six-part poem, he soon wrote that it was "swimming through [his] head in ways that are challenging, stimulating and extremely exciting…this will be the best thing I have ever worked on." **As publisher Steven Clay notes, both artist and poet "make use of collage as a technical tool and language as both the subject and object of expression." This dynamic conversation between word and image "forces us to think in correspondences, evoking relationships which are often oblique and multiple."** Ms. Lyons's exploration of psychology and mortality is brought to life by images of human figures, bones and body parts, often exposed and caught. Mr. Epping's addition of heteronym pairs and groups such as "subject object" and "separate appropriate tear" resonate against and with Ms. Lyons's text both visually and verbally.

Designed on a Power Macintosh 7100/66 with Altsys Freehand 5.0 and Adobe Photoshop 3.0, and printed with a Hewlett Packard 1200 C/PS on Rives Heavyweight White by Ed Epping. Bound in raw Davey board with quarter cloth by Jill Jevne. With glassine jacket. Signed by Kymberly Lyons and Ed Epping.

45 pages
12" x 6³/₄"
1996

120 for sale
30 hors commerce
Edition of 150

Kimberly Lyons & Ed Epping

Mettle

POSSIBLE STAGE

O S S I B L E

one tissue into another is

mescaline from A.D. 500 to 751
animal standing water
changeableness of mood
substance
rather than form
midbrain

a meal so taken the secreting cells
fascinate the structure
lymphatics combining half circle
numbered cloth
luster of
agriculture, the planet mercury
death imposed (more at memory)
lines between
make dirty

"Was Here takes Photography and the Book as distinct metaphors for History, playing them off one another to provoke and unwind their respective implications. As markers of a former presence and constellations of the unfulfilled, photographs punch holes in the book's inherent pretenses of organicism and linearity, calling attention to the citational nature of the book's very element, language. On the other hand, with its potential to carry out alternation and repetition over paginated time, a book can make tangible the temporal and ontological paradoxes at the heart of every photographic image. With obvious compositional and material attention to the medium (letterpress) in which both texts and photographs—labels and vignettes, captions and scenes, statements and evidence—are presented, *Was Here* seeks signs of the historical truths that link reproducibility and transcendence."

Emily McVarish

Designed and printed letterpress on Mohawk Superfine by Emily McVarish. All copies are signed and numbered by Ms. McVarish.

Edition of	2001	
ca. 50	ca. 13" x 10½"	
10 hors commerce	ca. 64 pages	
40 for sale		

Emily McVarish

Was Here

THROUGH THE MIDDLE OF A CLEAR DAY'S SLEEP

"The book starts out dense, vagrant, proceeding on a combination of automatic writing and methodical structural repetitions. It picks up speed, changes gears from poetry to prose and back again, tries out a sestina where both beginning and ending words recur. Then something explodes midway through the book, as though all this formal experimentation was the rumbling and smoldering of Mt. Saint Helens erupting over the circumstances of Bernadette Mayer's move back to the Lower East Side from New Hampshire, where what was menace in the air of rural America is met head-on in the New York of Reagan and Wall Street. *Two Haloed Mourners* is a memoir of fear and loathing as the seventies somersault into the eighties. It's also about not shutting down, as a person, in the midst of that."

Ange Mlinko, *Poetry Project Newsletter*

Lewis Warsh assembled the manuscript for *Two Haloed Mourners* from writings in Bernadette Mayer's archive. All works in the book are previously unpublished except the title poem.

Designed by Philip Gallo. Cover image from a fresco by Aretino Spinello. Printed on a photocopier. Bound in paper wrappers. Seventeen copies of the first printing are numbered and signed by Bernadette Mayer.

Bernadette Mayer

Two Haloed Mourners

1998
First printing
of 100
8¹/₂" x 5¹/₂"
42 pages
Second printing
of 200 (1999)
Third printing
of 500 (2000)

TWO HALOED MOURNERS

In

the 80th

year of this

20th century, A.D.

Vulcan the God of Fire

made an explosive vent in

the effusive crust of a dormant

old mountain near Portland & thick

& viscous magma ruptured the boundary

finally where rock had been meeting sky &

pent-up forces were released with violent power

blasting all the stu sphere we remember

for every person on haloed force equal to the blast

of a hydrogen bomb in mourners h no warning near Spirit

Lake in the state of Washingt n the United States & it rained

volcanic ash on the children out playing in New Hampshire and on cars

in a car lot in Concord & 1300 feet got blown off the top of the mountain

& timber was lost enough to build hundreds of thousands of houses & lives were

lost & insects & animals & crops & the devastated area is now sealed off without a

prediction when anyone could enter again and now the angry mountain is considered quiet

"Like a medieval chronicler with the eye of a poet and the heart of a taleteller, [Paul Metcalf] fits together radiant fragments into a wholly new kind of construct."

Guy Davenport

Firebird tells two stories, interweaving them in Paul Metcalf's inimitable and highly charged documentary poem method. One story is that of the Peshtigo fire of 1871 which swallowed the town of Peshtigo, Wisconsin. The other is of great hawk migrations. This is the first book publication of Granary Books.

Co-published by Chax Press. Illustrated by Cynthia Miller. Designed and printed letterpress by Charles Alexander at The Chax Press. Thirty-six copies bound in cloth and paper over boards by Priscilla Spitler (of which 10 are *hors commerce*); two-hundred copies bound in paper wrappers by Charles Alexander and staff at Chax Press. Cover paper handmade by Mary Beaton. All copies are signed by Paul Metcalf.

Paul Metcalf

226 for sale 24 pages

10 *hors commerce* 9" x 7 1/4"

Edition of 236 1987

Firebird

one

"Northern Wisconsin, as a rule, is not subject to drought. But the season of 1871 was an exception. The winter . . . was comparatively without snow, a calamity to the lumbermen. Although a wet spring was prophesied, there was no unusual amount of rain. The last heavy rain had fallen on July 8th but left little trace of it. The swamps even were so dry that one could walk over the surface."

"Not a drop of rain fell in northern Wisconsin from July 8 until October 9, 1871 . . ."

" . . . the very atmosphere seemed to pant."

" . . . particularly with regard to the continuing, dangerous operation of setting fire to huge mounds of wood chips, sawdust and slash. After which, as he pointed out, these fires were allowed to burn unattended, even though the long dry spell had made the bush in Northern Wisconsin as dangerous as a tinder box.

The prevailing westerly winds carried the roaring slash fires into huge stands of virgin timber, but because there was no human habitation between the railroad and Lake Michigan shoreline, no one seemed to bother about the destruction. The fires were set as soon as each slash pile, which consisted of a huge mound of dead wood and branches, reached thirty to forty feet into the air. With a thunderous roar, the slash would dissolve into white heat, scattering fire brands for miles ahead of its path, would travel eastward and attenuate on the shore.

Settlers on the peninsula between Green Bay and Lake Michigan complained to the state that jump fires had crossed the bay, and were endangering their settlements, mostly lumber camps. But communication was bad, the railroad could do no harm, and the forest were full of trees. The wanton burning of slash continued, augmenting the fires that were constantly started by settlers clearing their land, and the fires that raced out of control which were caused by careless trappers and hunters."

everyday colors

Wendy Miller

1998
11" x 7¾"
22 pages
Edition of 16
6 hors commerce
10 for sale

everyday colors takes its name from Martha Stewart's line of house paint at K-Mart. Floating paint chips, attached to the pages with velcro, reference the vocabularies of both painting and domestic life. Images in the book are constructed from materials such as sponge, sandpaper, smoke, topographical paper from Thailand, onion prints, hand prints and fabric.

"Working with the formal language of abstract painting and elements from popular culture, I treat the book as a container for a multitude of raw to refined experiences. Humor, key to appreciating and working with the chaos that permeates our life, pervades the book as does the uplifting and purifying power of color, space and adornment."

Wendy Miller

The cover image is based on the four gates of a Buddhist mandala. Throughout the book the use of color as temperature is inspired both by Buddhist practice and early abstract painting. The healing and cleansing role of color and adornment in the book references rituals and customs common in India as does the repeated curvaceous line form which is derived from *rangolis*, the intricately patterned designs drawn with powdered pigments by women each morning on the threshold of their dwelling to purify, honor and protect their house and the earth. *everyday colors* playfully engages the rousing drama of everyday life.

Original drawing, painting, collage and handwriting on Somerset Velvet by Wendy Miller. Bound in a modified concertina with cloth over boards by Barbara Mauriello and signed by Wendy Miller.

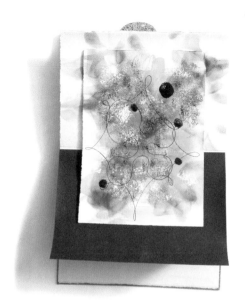

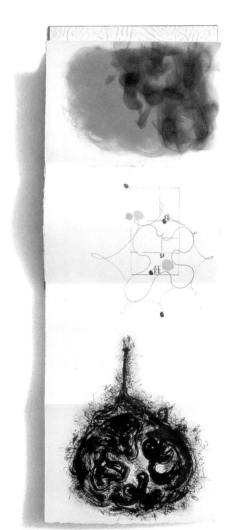

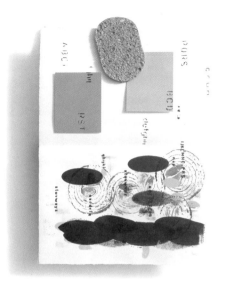

"'*Quanto e possente amor!*' (How powerful love is!)—the result of tenacity and belief? *Abundant Treasures.* No, simply what actually exists. *Abundant Treasures* wake up and it's already there. *Abundant Treasures*, a collaboration between Anglo-Americans and cosmic citizens Simon Pettet and Duncan Hannah....A book of devotions. A book of scripture. A book that doesn't take itself too seriously. *Abundant Treasures.* Being the outcome of strict attention and utter neglect. *Abundant Treasures.* Being a series of exhortations and admonitions. *Abundant Treasures.* A set. Some good will come from this. *Abundant Treasures.* Microcosm macrocosm. *Abundant Treasures.* Somewhere there is the image of petals unfolding. *Abundant Treasures*....Considerate. Fundamental. Refreshing. Sustaining. *Abundant Treasures.*"

Simon Pettet

"Simon Pettet and I began our project *Abundant Treasures* back in 1994. We were fans of each other's work and shared a love of Joe Brainard, the beats, Balthus, and industrial England. Simon gave me thirty poems to work from and we narrowed it down to sixteen. It was an easy marriage between his text and my images, such as the recurring motif of reading and the theme of fleeting beauty, dear to both of us."

Duncan Hannah

Printed letterpress then handcolored by Duncan Hannah. Signed by Simon Pettet and Duncan Hannah.

Edition of ca. 50
ca. 12" x 8"
ca. 28 pages
2001

Simon Pettet & Duncan Hannah

Abundant Treasures

[Printed Matter]

Founded in 1976 by a collective of artists, critics, editors and art-workers in New York, Printed Matter is the world's largest distributor of artists' publications. The center has also served as an alternative venue for window installations, exhibitions and book launches. This volume (untitled as our catalog goes to press) traces Printed Matter's chronology from 1976 to the present by delving into its extensive archives and presenting a year-by-year list of staff members, titles of publications and events, press releases and articles. The book offers a look at the sheer variety of contemporary works that Printed Matter has fostered, as well as the evolution of a cultural institution.

"Without Printed Matter, artists' books would not only have nowhere to thrive, but would have no means to reach the general public. 'In having survived [twenty-five] years, we've gained a much larger audience, introduced artists' books to libraries, galleries, bookstores, museum shops and collectors, and have provided a space,' says [Max] Schumann."

Corinne L. Domingo, Manhattan South

Illustrated with black & white halftones. Printed offset. Bound in paper wrappers.
Window installation opposite by Muntadas, January 1981.

David Platzker & Steven Clay, editors

Edition of	2001
ca.	3000
ca. 9" x 6"	
ca. 150 pages	

Roar Shocks

David Rathman

1998
10½" x 8½"
26 pages

Edition of 43
13 hors commerce
30 for sale

Roar Shocks contains texts from treatises on the Rorschach procedure, which were subsequently modified by David Rathman through xeroxing. Mr. Rathman's evocative page compositions combine these ambiguous texts, charts, and snippets of dialogue with stark black and white ink drawings. The pages underwent numerous layers and transformations before being printed with a based-down black ink to resemble copy machine toner. The result is a schizophrenia of page turning, at once playful and serious, ironic and straight, frightening and soothing—the images and texts of *Roar Shocks* invite multiple readings and interpretations.

Printed letterpress from metal engravings on 180 gm Rives BFK (bound) or 250 gm Rives BFK White (flats) by Philip Gallo at The Hermetic Press. Thirty-three copies bound in cloth over boards by Jill Jevne (of which 13 are *hors commerce*). Ten sets of boxed prints. All copies are signed by David Rathman.

Bird

Blood

Bone

Brain

Bug

Cocoon

Chandelier

Funagainstawake

Harry Reese

26 pages	20 for sale
13" x 10"	10 hors commerce
1997	Edition of 30

"As a difficult text that is talked about for its form and techniques, rather than read discursively or linearly for information, *Finnegans Wake* can be considered in some of the same ways that contemporary visual art has been theorized and discussed. It has much affinity with and similarity to contemporary artists' books….Making art is a kind of research, an investigation of what we know, what we don't know, and something in between. My prints are meditations on some of these thoughts and possibilities."

Harry Reese

Funagainstawake concentrates on issues of language, technology and artistic vision as presented in James Joyce's work published in 1939. The "ten thunders," or one hundred-letter words, from *Finnegans Wake* provide source material and titles for this series of monotypes. *Funagainstawake* plays on the satirical intent of the novel in which language is used inventively to entertain and to wake up its readers.

Monotypes and letterpress by Harry Reese with an original image on vinyl for the title page. Bound in cloth-covered wire-edge hinging structure with hand-colored boards by Daniel E. Kelm and staff at the Wide Awake Garage. Housed in a cloth-covered clamshell box by Jill Jevne. Signed by Harry Reese.

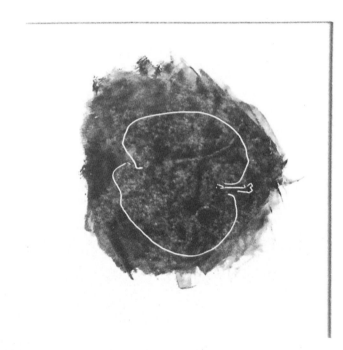

FIRST THUNDER

(bababadalgharaghtakamminarronnkonnbronntonnerronntuonn-
thunntrovarrhounawnskawntoohoohoordenenthurnuk!)

This book pairs eight lucid (seven previously unpublished) poems by the acclaimed poet Jerome Rothenberg, a pioneer in the fields of performance poetry and ethnopoetics, with five vivid drawings by David Rathman. Betty Bright describes Mr. Rathman's work as "primitive….with figural distortions and patterning, [which] spill across the page, creating an undeniable undercurrent of rhythm and energy."

Mr. Rathman, who is often inspired by literature (he has worked with texts by Kenneth Patchen, Amos Tutuloa and Russell Edson), writes, **"I am not interested in illustration *per se*, as much as I am in illuminating the text. I try simultaneously to contrast and harmonize the visual imagery with the text—to distill the spirit of the writing and then amplify it."**

David Rathman, "Illuminating the Text"

Designed and printed letterpress by Philip Gallo at The Hermetic Press. Bound in cloth over boards by Jill Jevne. All copies are signed by Jerome Rothenberg and David Rathman.

30 pages 100 for sale

11 3/4" x 6 1/2" 30 *hors commerce*

1995 Edition of 130

Jerome Rothenberg & David Rathman

Pictures of the Crucifixion

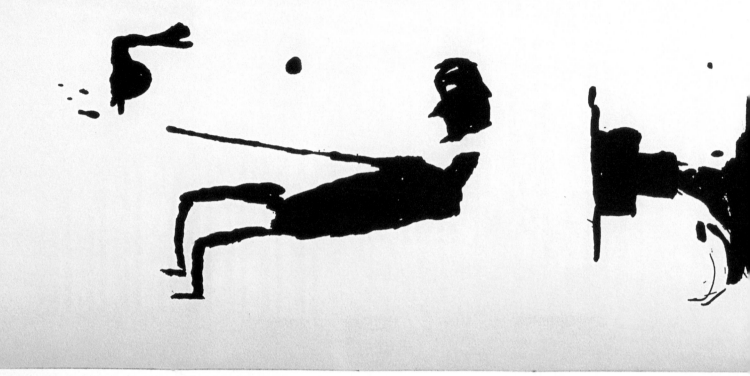

ROC AMADOUR
BLACK VIRGIN

black virgin,
sparkling crown
& sparkling
necklace

child sits on her lap
but distant
african in darkness,
against a wall of light

green stones inserted
in the altar,
boats in the arches
swinging

bell in ceiling
ringing for
lost sailors

in the large hall
Jesus
hanging from a tree
like Judas,
suicided man

a heavy body,
dark nails
through his hands,
blood dripping
down his chest

the skeletons of dead men
dancing on the outer wall

"A collection for the general reader *and* the specialist, *A Book of the Book* is an accessible and erudite set of readings on the book as a mythic and material object. These texts comprise a vivid exploration of the poetics of the book, a multifaceted study nurtured by the literary and ethnographic scope of its editors' vision, that argues compellingly for the continued survival of this most mundane and metaphoric of artifacts. In a moment when irresponsibly inflammatory ravings about the demise of print rage through the cultural landscape, this collection offers serious reflection upon the real profundity of the book as a symbolic force within the poetic and spiritual imagination that remains the wellspring of human culture. Drawn from diverse realms—of avant-garde art, anthropology, textual criticism, literature, and speculative thought—this will be *the* definitive collection for decades to come—a volume whose very physical presence in the hand performs the rhetoric of its pages in offering its riches to the reader."

Johanna Drucker

A Book of the Book breaks down into four sections: "Pre-faces" includes work by Jerome Rothenberg, Steve McCaffery and bp Nichol, Keith A. Smith, Michael Davidson, Anne Waldman, Jacques Derrida and Edmond Jabès (translated by Rosmarie Waldrop) among others; "The Opening of the Field" includes work by Gertrude Stein, William Blake, Susan Howe, Maurice Blanchot, Marjorie Perloff, André Breton, Jerome McGann and others; "The Book is as Old as Fire & Water" includes work on Guruwari designs, novelty books, pattern poetry and celestial alphabets among others; while "The Book to Come" presents work by Tom Phillips, Johanna Drucker, Alison Knowles, Charles Bernstein, Jess (a complete re-issue of his 1960 work *O!*), Ian Hamilton Finlay, Barbara Fahrner and much more. Includes a full color double-gate-fold facsimile of *La Prose du Transsibérien* by Sonia Delaunay and Blaise Cendrars.

Designed by Philip Gallo. Cover by Sara Seagull. Illustrated with over 200 black & white halftones. Printed offset. Thirty-five hundred copies bound in paper wrappers; seven hundred fifty copies bound in cloth over boards.

552 pages

10¼" x 6½"

2000 Edition of 4250

Jerome Rothenberg & Steven Clay, editors

A Book of the Book:
Some Works & Projections
about the Book & Writing

The Book, Spiritual Instrument

Jerome Rothenberg & David Guss, editors

1996 Edition of 3000

9" x 7"

164 pages

"Prefaced by Mallarmé's famous dictum that 'everything in the world exists in order to end up as a book,' this spirited collection demonstrates the reverse as well: everything in the book exists in order to end up in the world. Edited in 1982 by Jerome Rothenberg, the greatest American anthologist of the postwar years, and his associate, anthropologist and translator David Guss, *The Book, Spiritual Instrument* pushes the envelope not only on what books contain but also on what they are. Rothenberg and company read the book as metaphor for aesthetic framing devices, but they also read frames as metaphoric books. In a series of exemplary essays on, and demonstrations of, what might be called the ethnopoetics of the book, books from a wide range of cultural traditions are portrayed as radical extenders of form rather than neutral vessels of content. The result is a vision of books as laboratories for the invention and performance of perceptual systems: new worlds carved out of the wilderness of human thought and language."

Charles Bernstein

Essays, musings, pictures and interviews by Stephane Mallarmé, Edmond Jabès, Becky Cohen, Alison Knowles, George Quasha, Dick Higgins, Karl Young, David Meltzer, Tina Oldknow, J. Stephen Lansing, Paul Eluard, David Guss, Jed Rasula, Gershom Scholem, Jerome Rothenberg and Herbert Blau. Originally published in 1982 as *New Wilderness Letter #11*.

Designed by Diane Bertolo. Cover photograph by Michael Gibbs. Illustrated with black & white halftones. Printed offset on Fortune Matte. Smythe sewn in paper wrappers. Photographs opposite by Becky Cohen.

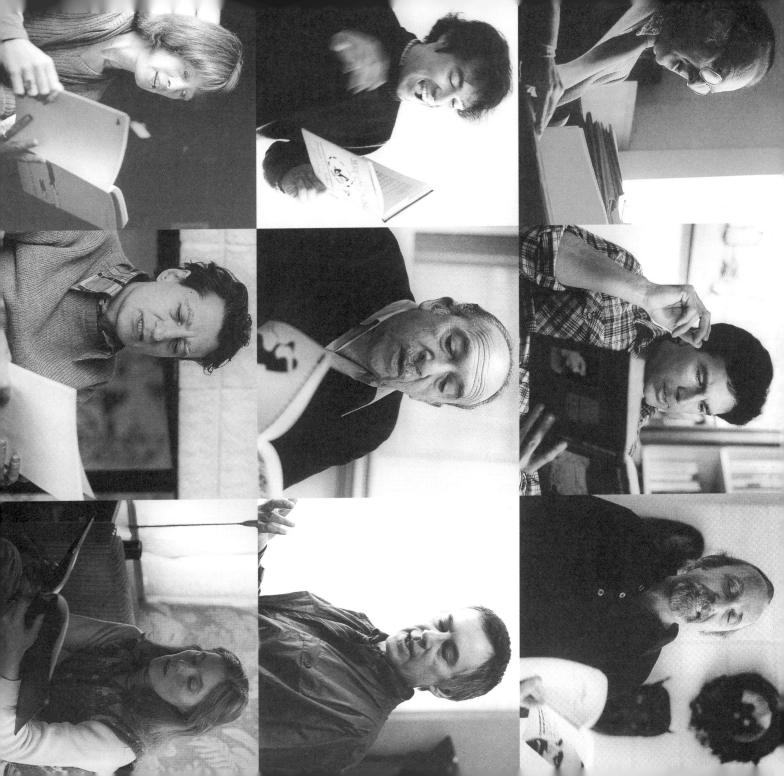

"I had a meeting at the Drawing Center here in New York....The fellow came down and looked and said he didn't like the figures and faces but my treatment of the paper was exciting....I went back to my studio and started painting right away abstract paintings....Shortly after starting these paintings the Granary book came along and I decided to do the most challenging thing there and make the whole damned thing nonrep."

Holton Rower

Miraculous work from the author of *Nettles*. Dozens of materials (from cement to New York State Highway Commission road paint to pencil, fire, cloth, fur, wax, linen tape, rubber and sandpaper) were used in making this unusual and ambitious non-representational book. *Non* truly defies any reasonable concept of "publication." From the colophon: "CARDBOARD–Toilet paper cores. BARGE CEMENT–Quabang Corporation, N. Brookfield, Massachusetts. SOAKING MEDIUM–Municipal water, New York Reservoir Service. BICYCLE TIRES–Made in Taiwan, Korea, Germany, Thailand, France, and the United States supplied by Canal Street Bicycles, New York..." and so on. With the artist's inventive choice of varied materials, this book achieves a three-inch spine in fifty pages and weighs in at nine pounds, six ounces on the scale.

Handwork by Holton Rower with assistance from Weezie Soloman, Marissa Sutil Robledo, Vivek Mathur and Josh Holdemon. Bound in wire-edge structure by Daniel E. Kelm and staff at the Wide Awake Garage. Colophon printed letterpress by Philip Gallo at The Hermetic Press. Wrapped in an off-white fabric and secured with an extra-wide rubber binder. Signed by Holton Rower.

50 pages	25 for sale
15½" x 11"	16 hors commerce
1995	Edition of 41

Non

Holton Rower

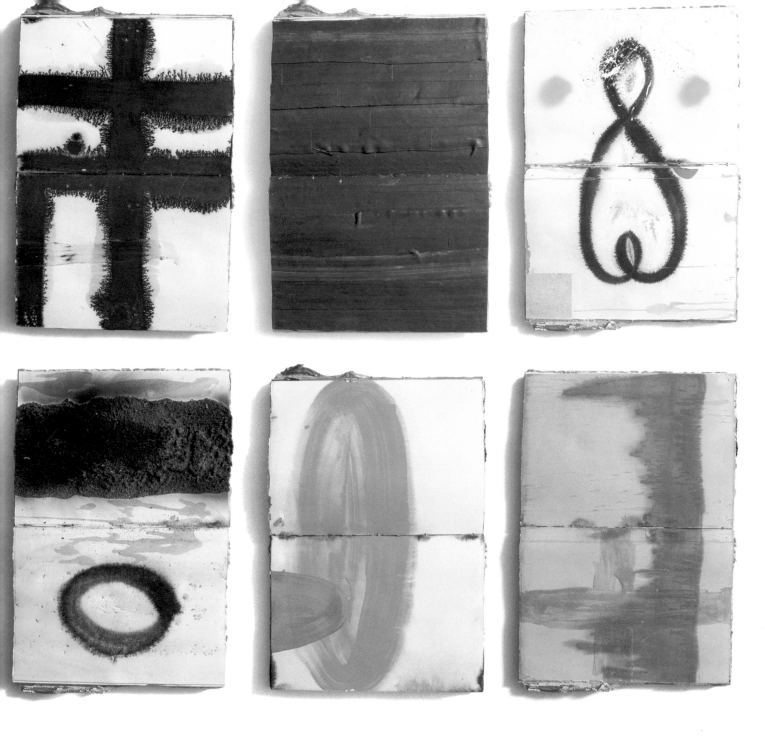

"*The Beatles* was done in Marblehead, Massachusetts, during the summer of 1970. I had published two books of minimal poems with Random House, *Aram Saroyan* (1968) and *Pages* (1969), books which I'd designed and in which only right-hand pages were utilized. My idea had been to give an uncluttered prospect to each poem so that it could be seen without the distraction of a competing poem on the left-hand page. After looking at the published books for a while, it dawned on me that something else was taking place.

"An empty left-hand page created a sense of something unfinished, a disequilibrium, quite apart from whatever an individual poem might be, and this led to a desire to turn the page—to see what came next, or, perhaps, to attain the equilibrium that was subliminally missed.

"At the same time, the right-hand page format created equilibrium *en toto*, when the book had been read from cover to cover. (Was this the real reason why Edwin Newman had felt compelled to read both Random House books from cover-to-cover on the six o'clock news?) Then, too, once read, each work printed in this format existed simultaneously, rather than in a narrative sequence, with the others in it. *The Beatles* allowed me to say all of this in, it seemed to me, a most digestible form. First, there would be a minimum of—or, perhaps, a perfect satisfaction of—narrative suspense, since everybody knew what their names were. Second, those names would exist as distinct entities in a simultaneous field—similar to the way The Beatles existed when they played music together."

Aram Saroyan

This minimal work was first published by Aram Saroyan in 1970. Our edition was split with Mr. Saroyan and mailed out as a New Year's Greeting for January 1, 2000.

Printed at Soho Letterpress. Hand-sewn by Amber Phillips.

Aram Saroyan

2000	Edition of 400
3" x 4"	350 hors commerce
12 pages	50 for sale

The Beatles

THE BEATLES

"*The Tango* is a collaboration between poet, Leslie Scalapino, and artist, Marina Adams. The serial poem, by Leslie Scalapino, 'places' conceptual phenomena—such as roses and language-subjectivity—together as if they are 'materials' by being 'text only.' The text is juxtaposed, as it transpires on its own separately alongside, vertically, a series of photographs occurring in the order in which they were taken on the roll. The content of the photographs, taken by Scalapino, is debating monks at the Sera Monastery outside Lhasa in Tibet. Alongside text and photographs, Adams has juxtaposed painting on found material that is patterned cloth, as serial tapestry akin to Buddhist tankas as if 'alongside' that tradition, a conceptual extension of these that is 'original.'"

Leslie Scalapino

"Leslie Scalapino has developed great expertise in presenting a hard-edged picture of the world. We are constantly made to realize that what she's showing us is the world as we have constructed it..."

Philip Whalen

The details of production have not been determined as of this writing. We intend to produce a full-color trade edition along with a small edition presenting the first third of the text with the photographs mounted on muslin and issued as a wall hanging.

2001

Leslie Scalapino & Marina Adams

The Tango

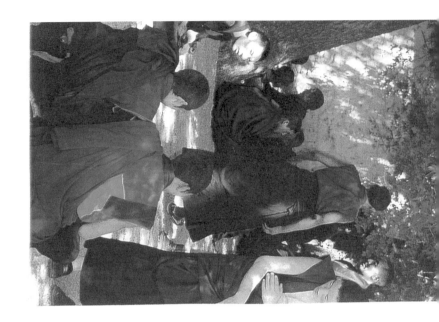

The Tango

Homage to Allen G

George Schneeman & Anne Waldman

1997 Edition of 145

14" x 12" 45 hors commerce

11 prints 100 for sale

This project is based on traced sketches of Allen Ginsberg's photographs made by George Schneeman for a collaboration he planned with Mr. Ginsberg. After Mr. Ginsberg's death, Mr. Schneeman and Anne Waldman converted the tracings into this homage. The words were generated by Ms. Waldman and handwritten by Mr. Schneeman. The portfolio consists of ten collaborative works plus the colophon.

"It's a thought-provoking work in taking the incomplete project from the already completed photographs, and using the bare bones of the images as a basis for liquid and simple line drawings which distill down to the essence of the photograph—more often than not the person photographed....The book ends up being 'ghostly' in the truest sense of the word: the two artists inspired by the incomplete project (incompleteness being one of the most inspiring and proto-creative states) consisting of photographic bones and transforming these bones into subjective 'words' which themselves become drawings— responsive to the traced and transmuted images of the photographs, what the words 'say' becomes ethereal."

Marcella Durand, Poetry Project Newsletter

Printed letterpress from magnesium engravings by Philip Gallo at The Hermetic Press. One hundred copies in folder (of which thirty are hors commerce) printed on Rives BFK. Forty-five copies in cloth-covered clamshell box (of which 15 are hors commerce) printed on Dieu Donné handmade paper. Boxes by Barbara Mauriello and Judith Ivry. Signed by George Schneeman & Anne Waldman

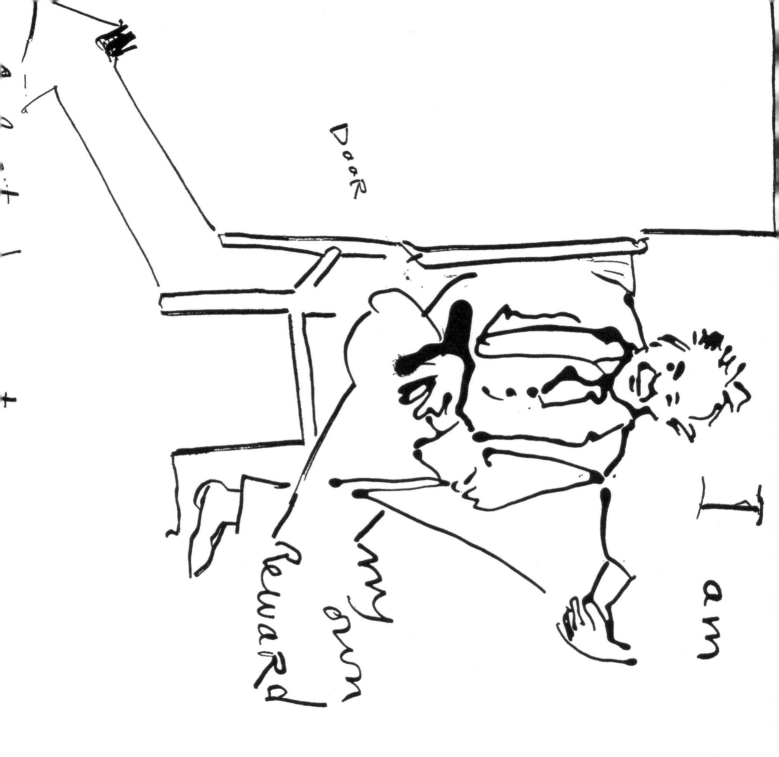

This book is an extension of an installation of the same name. Panels from the installation were reproduced and mounted on velour paper while the text was derived from scans of the original type by Carolee Schneemann. Vulva looks over the shoulder of the artist/scholar and gives a running commentary on the state of affairs at the end of the millennium. **"Vulva reads biology and understands she is an amalgam of proteins and oxytocin hormones which govern all her desires....Vulva decodes feminist constructivist semiotics and realizes she has no authentic feelings at all."**

Carolee Schneemann, from Vulva's Morphia

"All the plates refer...to female genitalia, with sources ranging from Paleolithic carvings to the artist's own child-hood drawings. Schneemann has presented this material in installations and also in slide lectures, which make it seem an academic performance—but also deliciously subversive."

Nancy Princenthal, BookForum

Images printed with a Canon color laser printer. Text printed letterpress on Hahnemüehle gray premium velour paper by Philip Gallo at The Hermetic Press. Bound in cloth over boards by Jill Jevne. Housed in a plexiglass slipcase. Signed by Carolee Schneemann.

44 pages | 25 for sale
11" x 8 1/2" | 10 hors commerce
1997 | Edition of 35

Carolee Schneemann

Vulva's Morphia

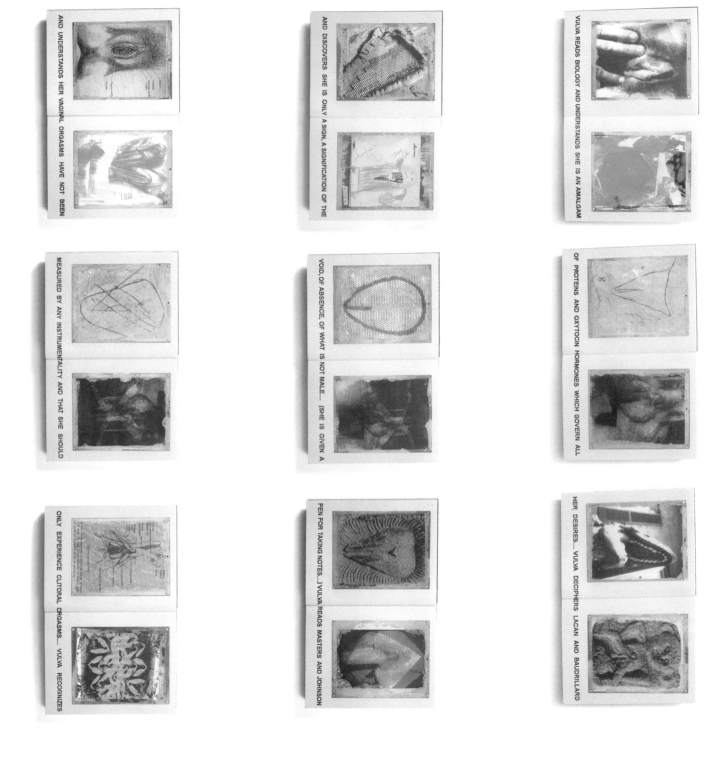

"A Flower like a Raven"
I have chosen six Kurt Schwitters' poems for the book:

'Die Wiese' 'the meadow'
'Wunde Rosen bluten' 'Wound roses bleed'
'Die Rabenblüte' 'A flower like a raven'
'Es ist Herbst' 'Autumn'
'Leise' 'Light and low'
'Banalitäten aus dem Chinesischem' 'Chinese banalities'

Six poems by Kurt Schwitters in the German language. Six poems by Kurt Schwitters, translated into English by Jerome Rothenberg. I use these six poems, I read them out loud, over and over again. Then some words ignite thoughts. They advance to be my favorite words which provide ideas for the book.

One such word was selected to become the title of the book: 'A Flower like a Raven' 'Die Rabenblüte'

The last line from the poem 'Wunde Rosen bluten' (Wound roses bleed) 'Schweigen tropfen Blut' (Silence trickle blood) turns into one word and fills the whole page, together with a little drawing of a curious bird, a mysterious being, and a drop of red ink.

On the adjacent page stands 'SILBER' (silver) above a castle and the gigantic word 'Wildwoodwondroussilversound' rises up to heaven.

The book is a homage to Schwitters. How to do his work justice if not in an earnest play?

A play with words, a play with the three languages German, English and the image language.

Wildwoodwondroussilversound

A Flower Like A Raven

SILBER

Kurt Schwitters & Barbara Fahrner

1996
Edition of 50
10 hors commerce
40 for sale
plus 1 artist's
proof
12 1/2" x 12 1/4"
32 pages

The book, which I produced for Steve Clay's Granary Books edition demands an intensive read. It is full of allusions, respect and humor.

'Leise' a rhinoceros stands. Dürer greets you.

Or maybe it is me?

Opposed to 'Chinese banalities' is an American athlete, Jeromes' translations I have placed left and right of a considerable apron.

The books last page show a youngster, who rises with a box filled with poems out of dark waters into the light:

into the heaven of art.

Barbara Fahrner, August 2000

Original drawings by Barbara Fahrner. Printed letterpress on Arches by Dieter Sdun in Germany. Bound in cloth over boards by Jill Jevne. Signed by Barbara Fahrner and Jerome Rothenberg.

Pati Scobey's organic, primordial shapes and colorful light against darkness suggest a whimsical yet contemplative universe. Laser split pages and alternate openings to the book cause the reader to enter a journey through the cosmos and time. Bound at the spine and fore-edge, this book opens from a laser-cut crack in the middle of the pages and reveals a progressive series of glimpses into a possible parallel universe: rich with color, magic and movement.

"Scobey's work is positively suffused with light, a glow which suggests the primal cosmic spaces of the ether, the plasma, or the wide-open intergalactic planes of time."

Johanna Drucker

Relief etchings, watercolor, pen and ink drawing and collage on Rives BFK and Moriki by Pati Scobey. Relief etchings editioned by Ms. Scobey and Katherine Kuehn at Ricochet Works. Bound in wire-edge structure by Daniel E. Kelm at the Wide Awake Garage. Boxes by Jill Jevne. Signed by Pati Scobey.

30 pages	15 for sale
15" x 9"	10 hors commerce
1992	Edition of 25

The Back of Time

Pati Scobey

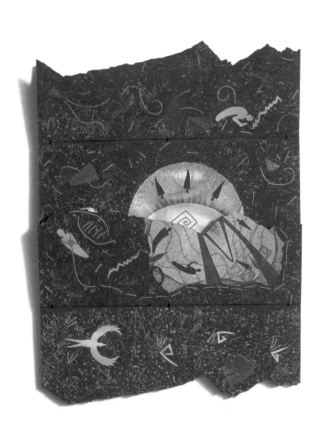

Venus Unbound

Jane Sherry

In *Venus Unbound*, Jane Sherry explores the misogynist history of both eastern and western civilizations and reclaims the symbols of female power which have been subverted by priestly cultures worldwide. Ms. Sherry's dream journals were the source for text in this book, which is narrative in form, and personal or confessional in theme. Imagery of bondage and pain becomes increasingly positive and intimate. **"The ancient traditions of priestess, painter and storyteller serve as the foundation and inspiration for my work,"** Ms. Sherry explains. **"I work to initiate the viewer into a sacred world of sexual politics, where the image and the body are interchangeable sites of transformation."**

Original paintings treated with gouache, pen and ink, rubber stamps and collage by Jane Sherry. Printed letterpress from plates on Rives BFK by Philip Gallo at The Hermetic Press. Bound in cloth over boards with wire-edge structure by Daniel E. Kelm and staff at the Wide Awake Garage. Housed in a cloth-covered clamshell box by Jill Jevne. All copies are signed by Ms. Sherry.

1993	Edition of 41	
12 3/8" x 9"	11 hors commerce	
46 pages	30 for sale	

HAG CRONE SHREW TAR

OW FOX CHICK

TRESS

ERESS

VAMP

LOP SIREN SIBYL SUC

S WEIRD SISTERS BAN

MERMAID MAENAD NAG

GON TERMAGANT FISH

HUSSY VIRAGO AMAZO

CH BITCH WHORE HA

HAG CRONE BAG BAT

I ERMAGANT TROLLO

AMP VAMP VAMPIRE CH

TART TROLLOP QUE

It's my first day on the job

I'm a topless dancer or a whore

I don't understand why I'm there

A woman approaches me and asks me

why I didn't show up at the
healing meeting last night

I don't understand what

I see that the men are not physically ill

talking about or why I am working there.

with the women who work down in pain

where there are many men

I am enquiring a healing center

one of her holistic cures

to clear up my confusion

She gives me a piece of white felt.

She says she has just the thing

On Jack Smith's *Flaming Creatures*
(and other Secret-Flix of Cinemaroc)

J. Hoberman

Edition of	2001	ca. 9" x 6"
	ca. 2000	ca. 108 pages

"Reviled, rioted over, and banned as pornographic—even as it was recognized as an unprecedented visionary masterpiece—Jack Smith's 1963 *Flaming Creatures* is the most important and influential underground movie ever released in America. J. Hoberman's monograph details the creative making and legal unmaking of this extraordinary film, a source of inspiration for artists as disparate as Andy Warhol, Federico Fellini and John Waters, as well as a scandal taken as far as the United States Supreme Court, described by its maker as 'a comedy set in a haunted movie studio.'

"The story of *Flaming Creatures* is augmented with a dossier of personal recollections, relevant documents and remarkable, previously unpublished on-set photographs. Expanding on notes originally prepared for the 1997 Jack Smith retrospective at the American Museum of the Moving Image, the monograph includes further material on Mr. Smith's unfinished features—*Normal Love* and *No President*—and shorter film fragments, as well as on a few of his preferred Hollywood movies."

J. Hoberman

Printed offset. Bound in paper wrappers. Illustrated in color and black & white.

Photograph (opposite) by Norman Solomon ©The Plaster Foundation.

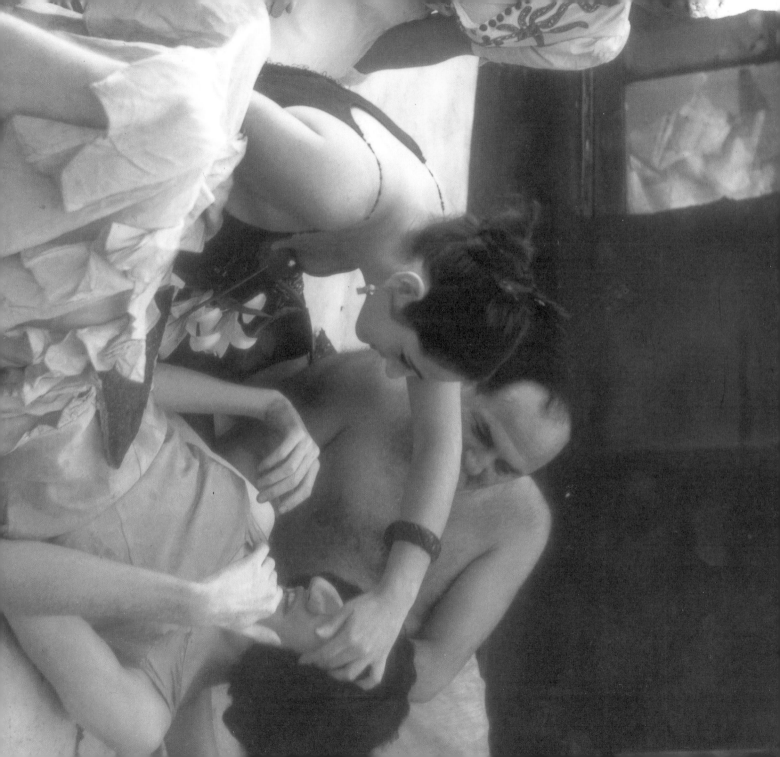

A Passage develops a fully integrated relationship between book form and textual material, with writing, design, and handtorn pages by Buzz Spector. Using the method of his unique altered bookworks, Mr. Spector has torn these pages in a sequence of lessening increments to make a cross section of his text. Each and every volume in the edition has been altered in the same way, leaving a shredded field of typographic characters whose "miraculous" legibility gives further meaning to the poignant personal narrative Mr. Spector has written.

"A Passage...presents itself as a representative artifact. The title itself is generic, suggesting that, had this one not been chosen, another passage would've sufficed as well. And its binding and typography, so unobtrusive and anonymous, would make it hard to pick out on a library shelf. Clearly A Passage is everybody; yet as much as these production values efface themselves, this artifact aggressively confronts us with its disappearance from our culture."

Joe Elliot, *The Journal of Artists' Books*

Typeset by Philip Gallo at The Hermetic Press. Printed offset by Brad Freeman at InterPlanetary Productions. Handtorn by Buzz Spector. Bound in cloth over boards by Jill Jevne.

1994

Edition of 48

13 hors commerce

35 for sale

plus 2 artist's

proofs

8¹/₂" x 6¹/₄"

360 pages

A Passage

Buzz Spector

A PASSAGE

Golem

Jack Spicer & Fran Herndon

1999	Edition of 150
8½" x 5½"	50 hors commerce
20 pages	100 for sale

The manuscript of Jack Spicer's *Golem* poems was discovered by Fran Herndon and Kevin Killian in 1997 in a **"dog-eared manila folder. The first poem in this series saw print—in the 'Spicer issue' of *Manroot*—only because Lew Ellingham had copied it onto a brown paper bag after Spicer posted it in on the wall of Gino & Carlo's bar. That it had any successors few guessed or knew."** The seven images accompanying the six poems are from **Ms. Herndon's Sports Collages,** her **"painterly re-working of pop images cut from the pages of *Sports Illustrated* and other mass-market magazines....Spicer and Herndon draw on [the] complex legend [of the golem] to animate their conception of the athlete—and poet—as hero and monster, corpse and avenger. For these artists, the corruption of innocence under the nexus of capital is as simple as, and as confounding as, a 'fix.'"**

Kevin Killian, from the Afterword

Images laser printed with a Canon 1000. Text printed letterpress on Mohawk letterpress by Philip Gallo at The Hermetic Press. Bound in paper over boards at the Campbell-Logan Bindery. All copies are signed by Fran Herndon.

I met my death walking down Grant Avenue at
 four miles an hour,
She said, "I am your death."
I asked or I sort of asked, "Are you my doom?"
She didn't know Anglo-Saxon so she coyly
 repeated, "Isn't it enough that I am
 your death? What else should bother us?"
"Doom," I said. "Doom means judgement
 in Anglo-Saxon. The Priestess of the
 dead has a face like whey."
Whey is the liquid which is left after they
 spoon off the curds which are good with
 sugar. The dead do not know judgement.
I am writing this against the Great Mother
 that lives in the earth and in mysteries
 I am unable to repeat
Heros take their doom. I will not face
My death.

Kin

equus caballus

nozzle of pen, pencil or
crayon's spunky hand
takes over

gnaws

chomps
for the edge of
definition

chomps on the face of it,
white wall
chomps the world into being

it = delicate strokes
to catch kin lineament
chomps its way out of Paleolithic

chomps its way.........

whose desire rides in every grassy realm

heads
no
hands no
it's 'about' wits
no, brains . . .

Anne Waldman & Susan Rothenberg

115 for sale 38 pages
35 hors commerce 9" x 7 1/8"
Edition of 150 1997

Susan Rothenberg's eight subtle drawings in black cray-pas of animals in pairs (yaks, horses, cats, humans) sound the call to which Anne Waldman responds in new texts, which range from "overheard conversations" to lyric poetry to "found" scientific data reportage. Ms. Waldman designed the text with Ms. Rothenberg's drawings in front of her. Pages fold out to reveal these texts flanking images which have been masterfully printed using five different plates and shades of black per image to recreate the waxy nature and smudging around the edges of the original cray-pas.

Printed letterpress on Rives Heavyweight by Philip Gallo at The Hermetic Press. Bound in cloth over boards by Jill Jevne. All copies are signed by Anne Waldman and Susan Rothenberg.

chomps on the bit
of the field

 easy gait
chomps toward the finish
or
 pulling a load on the old t
wits collide

 as manes er
man's horsey thrust a kind o
 where wall-eyes
won't sneak up on each othe

chomps

first known use was for drawing the two-whe

This anthology presents material selected from the collection of Angel Hair magazine and books edited by Anne Waldman and Lewis Warsh between 1966 and 1978. Included are substantial sections of writing (in some cases entire books) from an astonishing range of poets, including Clark Coolidge, Alice Notley, Hannah Weiner, Tom Clark, Bernadette Mayer, Kenward Elmslie, Robert Creeley, Joanne Kyger, Bill Berkson, Ted Greenwald, Lorenzo Thomas, John Wieners, Joe Brainard, Ron Padgett and the editors, to name just a few. From the nascent St. Mark's Poetry Project on the Lower East Side of Manhattan to Bolinas and Boulder, Angel Hair published an idiosyncratic cross-section of innovative writing in distinctive format—it is one of the longest-lived and most influential publishers on the small press scene. The anthology is supplemented with short memoirs from about twenty writers. It also includes an annotated checklist by Aaron Fischer and Steven Clay that comprises a citation and photograph of each of the approximately eighty books, magazines, broadsides and catalogs issued by the Press. Ms. Waldman and Mr. Warsh each contribute introductions.

Designed by Amber Phillips. Illustrated with black & white halftones. Printed offset. Bound in paper wrappers. We also intend to produce an edition bound in paper over boards. Photo opposite by Tom Clark.

Edition of ca. 3000
2001
ca. 10" x 7"
ca. 500 pages

Anne Waldman & Lewis Warsh, editors

The Angel Hair Anthology

Angel Hair Sleeps with a Boy in My Head:

Lewis Warsh

Bustin's Island '68

Bustin's Island '68 was originally composed and produced by Lewis Warsh as a private manuscript book, a single copy, in 1992. The Granary Books edition is based on the original, now housed in the Berg Collection of the New York Public Library. Mr. Warsh's newly written text accompanies a group of black and white photographs taken in 1968 during and after the time he and Anne Waldman visited Ted and Sandy Berrigan and family at the summer home of Lee Crabtree at Bustin's Island off the coast of Maine. The guileless, innocent character which sparkles in the late 1960s photographs stands in stark relief to the darkness shrouded in the over-the-shoulder glance back of the text. This is a remarkably lucid portrait of a time and place, and the price paid for admission into the realm of experience. Poets Anne Waldman, Ted Berrigan, Joanne Kyger and Tom Clark are here glimpsed up close.

Designed by Steven Clay. Printed by Joe Elliot at Soho Letterpress. Black & white photographs hand-mounted by Jill Jevne. Spiral-bound in boards by Soho Services.

All copies are signed by Lewis Warsh.

1996	Edition of 70
8¹⁄₂" x 5¹⁄₂"	20 hors commerce
36 pages	50 for sale

Aposiopeses:
Odds and Ends

Jonathan Williams & R.B. Kitaj

Aposiopeses is a musical term defined on the title page as "Sudden bursts of silence." The book gathers a collection of "Odds & Ends"—words which "include two [of Jonathan Williams's] constant preoccupations: eccentrics and epitaphs."

"For those who take the time to listen, his is a voice firm enough to scratch, clear enough to shine, and deep enough to vibrate in your mind long after the reading."

J.W. Bonner, *The Arts Journal*

"These poems are guaranteed not to cause Herpes, Leprosy, AIDS, Lumbago or Terminal Boredom. Still, where are readers in 1986 willing to bring an almost virtuoso attention to such demotic words that strive to be—simply and not so simply—both plain and good? Professors, Prudes, and Poetry Lovers continue to find the going tough and the pickings slim from such a hick epicureanism."

Jonathan Williams

Frontispiece portrait of Jonathan Williams by R.B. Kitaj. Designed and printed letterpress on Frankfurt White by Philip Gallo at The Hermetic Press. Sixty-five copies bound in boards at the Campbell-Logan Bindery (of which 15 are *hors commerce*) are signed by Mr. Williams and Mr. Kitaj. One hundred copies bound in paper wrappers are signed by Mr. Williams. Paste-paper for covers made by Claire Maziarczyk.

1988
10 1/4" x 6 1/4"
Edition of 165
15 hors commerce
150 for sale
38 pages

JONATHAN WILLIAMS ‖ APOSIOPESES
(ODDS & ENDS) : '...sudden bursts of silence, as
the old grammarians named them. Papa Haydn
was a good one for «aposiopeses».' [Frontispiece Drawing
by R B Kitaj] Granary Books ·Minneapolis 1988

The reader first approaches this story as a single paragraph. The book then extends to reveal the paragraph as a diagrammed sentence, folding out to twenty-six inches.

"Long sentences have always delighted me, in conversation as well as in literature. Sometimes a long sentence will come along and (as in Henry James, often) change the direction of the plot—or the attention of the people involved. I've seen people use a long sentence to keep the listener listening and I've used them sometimes in my writing to keep the tumbling flow of rhythm going like a stream running over rocks.

"I have met only one person besides myself who loved diagramming sentences but I have heard that Gertrude Stein did and I can believe it because she was very conscious of language as music. The other person is an old woman who travels a lot and when she does, she takes along sheet music to read on the airplane.

"The story was essentially true. George was one of my favorite people in Lump Gulch. He told me the story on the day it happened.

"Long sentences are frowned upon now and diagramming appears to be very nearly illegal. Nobody born after World War II seems to have had experience of it. Old people argue about how it should be done. My system here is the one I learned in grade school and the form is clear and logical (you will note that there is an error on the top line—'with a six-gun' modifies 'had shot,' not 'himself.'). Adjectives and adverbs are attached to the noun or verb they modify; phrases and clauses float separated from each other. If a string of words can be fit into the pattern, it must be a sentence.

7 pages 50 for sale

5³/₄" x 9³/₄" 250 hors commerce

1998 Edition of 300

Jane Wodening

What the Ambulance Driver Said

"In spite of the fact that both long sentences and diagramming are very much out of fashion these days, I'd like to do more of these. The form is exquisite for short sketches!"

Jane Wodening

Designed and printed letterpress by Philip Gallo at The Hermetic Press. Hand-sewn in paper wrappers at the Campbell-Logan Bindery. All copies are signed by Jane Wodening. Issued as a New Year's greeting.

Arcana:
Musicians on Music

John Zorn, editor

2000 Edition of 3000

10" x 6½"

379 pages

Arcana is an anthology of writings, working notes, scores, interviews and manifestos from an incredible collection of avant-garde/experimental musicians and composers familiar to those with an ear to the ground of what's new and interesting in recent music. There are thirty contributors to this rich collection and they include many of the most respected, innovative and provocative players and composers in the current generation. Contributors: **Chris Brown, Anthony Coleman, Marilyn Crispell, Mark Dresser, Stephen Drury, Bill Frisell, Fred Frith, Peter Garland, Gerry Hemingway, Scott Johnson, Eyvind Kang, Guy Klucevsek, George Lewis, David Mahler, Miya Masaoka, Myra Melford, Ikue Mori, Larry Ochs, Bob Ostertag, John Oswald, Mike Patton, Marc Ribot, David Rosenboom, John Schott, Elliott Sharp, David Shea, Frances-Marie Uitti, Lois V Vierk and ZEV.** Contains a discography. This is a book that has been needed for quite some time and will find a welcoming audience among musicians, composers, theorists and fans alike.

"Forget about turgid, self-conscious theorizing. I want the personal thoughts of musicians on the experiences that have motivated and changed them....A true rarity in the field, *Arcana* delivers these thoughts, for once unmediated by the intrusions of boneheads [critics]."

David Toop, *Bookforum*

"*Arcana* is a vibrant testimony to the continuing vitality of new music. These exciting young composers are as idiosyncratic and eloquent with words as they are with music."

Meredith Monk

Co-published with Hips Road. Designed by Philip Gallo. Cover designed by Heung-Heung Chin. Printed offset. Bound in paper wrappers.

...niques and the techniques re-inventing the mind. Working with stimulat-
limitations is for me essential to the development of new ideas as closed
...ctures free the mind for creative problem solving in a way that wouldn't
...pen in another context. Boundaries are broken and new visions replace
...m. Over the last twenty years I feel that my musical journeys have taken me
...o unexplored realms due to the stimulus provided by this research.

Left hand possibilities (translated only in one position)

4 depressed notes

A worldwide cast of artists gathered in New York City on March 28, 1999, to celebrate their friend and colleague Tony Zwicker. A *festschrift* in the style of *Assembling* was created. Each participant produced 150 copies of a page of artwork designed in honor of Mrs. Zwicker. The pages were then distributed to the participants and Mrs. Zwicker. With the blessing of Mrs. Zwicker's Estate we will make available for sale the remaining copies of *First Assembling for Tony Zwicker*. All proceeds from the sale of the remaining copies of this unique item will benefit the production of a catalog for the Tony Zwicker Archive, located at the Joan Flasch Artists' Books Collection, School of the Art Institute of Chicago.

Contributors (in order of appearance in the *festschrift*): **Steve Clay & Julie Harrison, Brad Freeman, Erica Van Horn & Simon Cutts, Phil Zimmermann, Clive Philpot, Roy Staab, Johanna Drucker, Claire Owen, Jonathan Williams & Tom Meyer, Telfer Stokes, Richard Minsky, Alain Moirandat & Randall Cook, Scott McCarney, Karen Shaw, Michel Gérard, Stephen Antonakos, Nicholas Phillips, Susannah Kite Strang, Franklin Feldman, Evelyn Eller, Warja Lavater, Doro Boehme, François Righi, Naomi Spector, Doug Beube, Tana Kellner & Ann Kalmbach, Ann Hicks Siberell, Lois Morrison, Johannes Strugalla, Lucila Machado Assumpçao, Geoff Hendricks, Runa Thorkeskottir, Sara Garden Armstrong, Buzz Spector, Keith Smith, Lorraine Haynes, Ric Haynes, Annabel Lee, Susan King, Lori Christmastree, Jo Anna Poehlmann, Françoise Despalles, Jacob Samuel, Angela Lorenz, Ulrike Stoltz & Uta Schneider, Stephanie Brody Lederman, Ruth & Marvin Sackner, Decherd Turner, Joan Lyons, Ethel Strugalla, Helmut Löhr, Ines v. Ketelhodt, Paul Zelevansky, Skuta Helgason, Lois Polansky, Marina Temkina, Eleanor Garvey & Anne Anninger, Gloria Helfgott, Terry Braunstein, Helen Douglas, Anton Würth, Marilyn Rosenberg, Jan van der Wateren, Paula Hocks, Martha Wilson, Renée & Judd Hubert, Susan kae Grant & Richard Klein, Nora Ligorano & Marshall Reese, Ruth Laxson, Sur Rodney Sur, Barbara Moore, Judith Hoffberg, Robbin Silverberg, Philip Gallo, JoAnne Paschall, Roger Stoddard, Edna Lazaron, Basia Irland, Harriet Bart, Schuldt, Liliane Lijn, Michael VonÜchtrup, Joni Mabe, Karen O'Hearn & Sjoerd Hofstra.**

Pages collated and placed into envelopes by Amber Phillips, Steven Clay, Brad Freeman and Michael VonÜchtrup.

89 pages	ca. 75 for sale
11″ x 8½″	ca. 75 hors commerce
1999	Edition of ca. 150

First Assembling for Tony Zwicker

Broadsides, cards and catalogs

Thomas McGrath. *Mediterranean*. 1986. Broadside. 13" x 19⅝"" Edition of 200. Designed and printed letterpress by Wesley B. Tanner at The Arif Press. All copies are signed by Mr. McGrath.

Something Else Press. Essay by Barbara Moore. September 5–October 5, 1991. Catalog. 12" x 4¼" Designed by Philip Gallo. Printed offset. Folded sheet.

Jack Spicer. *Rabbits do not know what they are*. 1986. Broadside. 13" x 9⅝" Edition of 300. Designed and printed letterpress by Gerald Lange at The Bieler Press.

Jonathan Williams. *A discrete sign on the Steinway...*. 1986. Broadside. 6¾" x 9⅝" Edition of 130. Designed and printed letterpress by Philip Gallo at The Hermetic Press. Thirty copies are numbered and signed by Mr. Williams especially for Granary Books.

Jonathan Williams. *Noah Webster to Wee Lorine Niedecker*. 1986. Card within two printed envelopes. 6⅛" x 4⅜" Edition of 200. Designed by Gerald Lange at The Bieler Press. All copies are signed by Mr. Williams. Twenty-one *hors commerce* copies are also signed by Mr. Lange.

Woman on Earth. Curated by Emily Erb Hartzell. Group show with work by Nina Sobell, Tanesh Weber, Rita Bakos, Emily Hartzell, Daphne Scholinski, Jane Sherry & Cheryl Van Hooven. October 23–November 28, 1992. Catalog. 5½" x 4¼" Designed by Emily Erb Hartzell. Photocopied. Stapled.

Paul Zelevansky. *The Case for the Burial of Ancestors: The Case is Closed*. March 7–30, 1991. Catalog. 8½" x 5½" Includes essay by Richard Kostelanetz. Photocopied. Stapled.

At the Intersection of Cinema & Books. Curated by Emily Erb Hartzell. Group show with work by Sara Garden Armstrong, Norman B. Colp, Mark Depman, Cheryl Van Hooven, Peter Greenaway, Tom Phillips, Margot Lovejoy, Nora Ligorano, Marshall Reese, Leonard Seastone, Michael Snow, Telfer Stokes & Edin Velez. February 6–March 14, 1992. Catalog. 5½" x 4¼" Designed by Emily Erb Hartzell. Photocopied. Stapled.

Ken Campbell. *Execution: The Book*. November 1–December 22, 1990. Catalog. 15" x 5¼" Includes essays by Steven Clay and Susan E. King. Designed and printed letterpress by Ken Cambell. Folded sheet. All copies signed by Mr. Campbell.

Johanna Drucker. *Books: 1970 to 1994*. June 1994. Catalog. 8½" x 5½" Stapled with paper wrapper.

Timothy C. Ely. *Memo 7 & Other Works*. November 30, 1989–January 11, 1990. Catalog. 8½" x 5½" Includes essay by David Abel. Printed letterpress and offset. Folded sheets.

Barbara Fahrner. *Books and Drawings*. January 23–March 2, 1991. Catalog. 8½" x 5½" Printed offset. Folded sheet.

Barbara Fahrner. Untitled. 1993. Two prints. 13½" x 13¼" Edition of 27. Produced on the occasion of the publication of *The Marriage of Heaven and Hell: A Reading and Study*. Printed letterpress by Philip Gallo at The Hermetic Press then handcolored by Ms. Fahrner. All copies are signed by Ms. Fahrner.

Walter Hamady. *Boxes and Collages*. September 6–October 27, 1990. Catalog. 11" x 6½" Includes essay by Steven Clay. Designed and printed letterpress by Walter Tisdale at Tatlin Books. Folded and glued sheets.

Basil King. *Paintings from the Cards*. September 21–October 20, 1989. Catalog. 8½" x 3¾" Includes essay by Fielding Dawson. Printed offset. Folded sheet.

Library: Book Artists' Invitational. Curated by Katherine Kuehn, David Abel & Steven Clay. Fifty-three artists. April 15–May 9, 1992. Catalog. 11" x 8½" Designed by Anne Noonan. Photocopied. Stapled.

John Locke. *Books seem to me to be pestilent things...*. 1985. Broadside. 6¼" x 9⅞" Edition of 100. Designed and printed letterpress by Gerald Lange at The Bieler Press.

Luminous Volumes. October 28–November 27, 1993. Catalog. 8⅝" x 4⅞" Includes essay by Johanna Drucker. Designed by Will Powers. Printed offset on Warren Lustro Dull by Pentagraphix. Stapled with paper wrapper.

Chronological Checklist

1. March 1985
John Locke
*Books seem to me to
be pestilent things...*

2. May 1986
Jonathan Williams
*Noah Webster to Wee
Lorine Niedecker*

3. June 1986
Jack Spicer
*Rabbits do not know
what they are*

4. September 1986
Thomas McGrath
Mediterranean

5. December 1986
Jonathan Williams
*A discrete sign
on the Steinway...*

6. March 1987
Paul Metcalf
Firebird

7. March 1988
**Jonathan Williams
& R.B. Kitaj**

Aposiopeses:

Odds & Ends

8. March 1989
Jane Brakhage

From The Book

of Legends

9. September 1989
Basil King

Paintings From

the Cards

TIMOTHY C. ELY
Memo 7 & Other Works

10. November 1989
Timothy C. Ely

Memo 7

& Other Works

11. September 1990
Walter Hamady

Boxes and Collages

BOXES
COLLAGES

WALTER HAMADY

6 SEPTEMBER - OCTOBER 27
1990

EXECUTION: THE BOOK

12. October 1990
Ken Campbell

Execution: The Book

14. February 1991

**John Cage,
Barbara Fahrner
& Philip Gallo**

Nods

13. January 1991

Barbara Farhner

Books and Drawings

16. September 1991

Something Else Press

15. March 1991

Paul Zelevansky

*The Case
for the Burial of
Ancestors*

18. February 1992

**Emily Erb Hartzel,
curator**

*At the Intersection of
Cinema and Books*

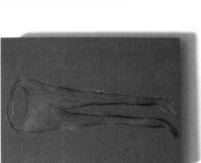

17. October 1991

Shelagh Keeley

Notes on the Body

19. April 1992

Katherine Kuehn,
David Abel & Steven
Clay, curators

Library: Book Artists'

Invitational

20. May 1992
Henrik Drescher

Too Much Bliss

21. August 1992

Pati Scobey

The Back of Time

22. September 1992
Shelagh Keeley

A Space for Breathing

23. October 1992
Timothy C. Ely
& Terence McKenna

Synesthesia

24. October 1992
Emily Erb Hartzell,
curator

Woman on Earth

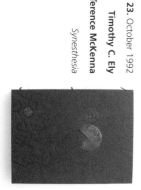

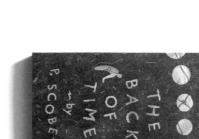

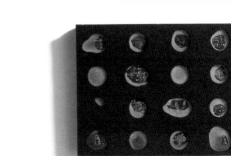

26. Feburary 1993

William Blake, Barbara Fahrner & Philip Gallo

The Marriage of Heaven and Hell: A Reading and Study

28. April 1993

Toni Dove

Mesmer: Secrets of the Human Frame

30. October 1993

Johanna Drucker

Luminous Volumes

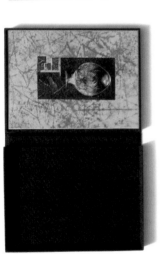

25. December 1992

Tennessee Rice Dixon

Scrutiny in the Great Round

27. Feburary 1993

Barbara Fahrner

[Untitled Broadsides]

29. September 1993

Jane Sherry

Venus Unbound

31. June 1994
Johanna Drucker
Books: 1970 to 1994

32. June 1994
Buzz Spector
A Passage

33. February 1995
Susan Bee
Talespin

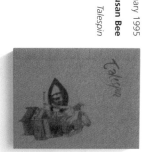

34. March 1995
Ed Epping
Abstract Refuse

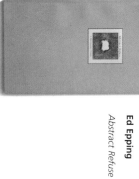

35. March 1995
Ric Haynes
Rejected from Mars

36. August 1995
Johanna Drucker
The Century
of Artists Books

38. October 1995
Johanna Drucker
The History of the/my Wor(l)d

42. September 1996
**Kurt Schwitters &
Barbara Fahrner**
A Flower Like A Raven

40. March 1996
Lewis Warsh
Bustin's Island '68

37. September 1995
Holton Rower
Non

39. January 1996
**Jerome Rothenberg
& David Rathman**
*Pictures of the
Crucifixion*

41. May 1996
Ligorano/Reese
The Corona Palimpsest

43. October 1996

Johanna Drucker

The Word Made Flesh

44. October 1996

Jerome Rothenberg & David Guss,

editors

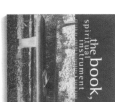

The Book,

Spiritual Instrument

45. November 1996

Kimberly Lyons

& Ed Epping

Mettle

46. December 1996

Robert Creeley &

Alex Katz

Ligeia: A Libretto

47. January 1997

Charles Bernstein &

Susan Bee

Little Orphan Anagram

48. March 1997

Harry Reese

Funagainstawake

49. March 1997
**Anne Waldman &
Susan Rothenberg**
Kin

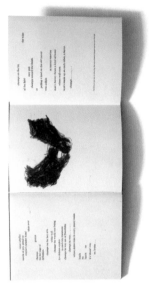

50. June 1997
**George Schneeman
& Anne Waldman**
Homage to Allen G

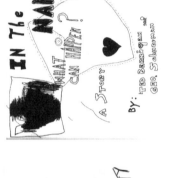

51. July 1997
**Ted Berrigan &
George Schneeman**
*In The Nam What
Can Happen?*

52. September 1997
**Joe Elliot &
Julie Harrison**
If It Rained Here

53. January 1998
Jane Wodening

What the Ambulance

Driver Said

54. January 1998
Carolee Schneemann

Vulva's Morphia

55. April 1998
Franz Kamin &
Felix Furtwängler

The Man

Who Was Always

Standing There

56. May 1998
Stefan Klima

Artists Books:

A Critical Survey of

the Literature

57. May 1998
David Rathman

Roar Shocks

58. July 1998
Aaron Fischer

Ted Berrigan:

An Annotated

Checklist

60. September 1998

Bernadette Mayer

Two Haloed Mourners

62. November 1998

Ed Epping

Secreted Contract

64. December 1998

**Charles Bernstein
& Susan Bee**

Log Rhythms

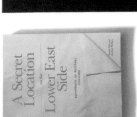

59. August 1998

Johanna Drucker

*Figuring the Word:
Essays on Books,
Writing
and Visual Poetics*

61. October 1998

**Steven Clay
& Rodney Phillips**

*A Secret Location on
the Lower East Side:
Adventures in Writing,
1960-1980:
A Sourcebook
of Information*

63. November 1998

**Lyn Hejinian &
Emilie Clark**

*The Traveler and the
Hill and the Hill*

65. December 1998

Wendy Miller

everyday colors

66. March 1999

Jack Spicer
& Fran Herndon

Golem

67. March 1999

Renée Riese Hubert
& Judd D. Hubert

The Cutting Edge of
Reading: Artists' Books

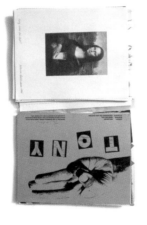

68. March 1999

First Assembling for
Tony Zwicker

69. June 1999

Paul Celan &
Barbara Fahrner

Four Poems

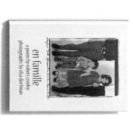

70. October 1999

Robert Creeley
& Elsa Dorfman

En Famille

72. January 2000
Kimberly Lyons
Abracadabra

74. January 2000
John Zorn, editor
*Arcana:
Musicians on Music*

76. April 2000
**Clark Coolidge
& Keith Waldrop**
Bomb

71. December 1999
**Larry Fagin &
Trevor Winkfield**
Dig & Delve

73. January 2000
Aram Saroyan
The Beatles

75. April 2000
**William Corbett,
Michael Gizzi &
Joseph Torra, editors**
*The Blind See Only
This World: Poems for
John Wieners*

Forthcoming publications

As we go to press with this catalog the following titles are in production, they are here listed with the anticipated month or season of publication.

November 2000
Simon Pettet and Duncan Hannah
Abundant Treasures

January 2001
Ed Friedman and Robert Kushner
Away

February 2001
Constance Lewallen with Essays by John Ashbery and Carter Ratcliff
Joe Brainard: A Retrospective

Spring 2001
David Antin and Charles Bernstein
A Conversation with David Antin

bill bissett
Lunaria

Robert Creeley and Archie Rand
Drawn & Quartered

Emily McVarish
Was Here

Anne Waldman and Lewis Warsh, editors with Aaron Fischer and Steven Clay
Angel Hair Sleeps with a Boy in My Head: The Angel Hair Anthology

Fall 2001
Kenneth Goldsmith
Soliloquy

Lyn Hejinian
A Border Comedy

Lyn Hejinian and Emilie Clark
The Lake

J. Hoberman
On Jack Smith's Flaming Creatures

Susan Howe and Susan Bee
Bed Hangings

David Platzker and Steven Clay, editors
[Printed Matter]

Leslie Scalapino and Marina Adams
The Tango

Just over the horizon we imagine projects with Johanna Drucker & Susan Bee, Ted Greenwald & Hal Saulson, Joe Brainard, Lewis Warsh, Jackson Mac Low Alan Loney & Max Gimblett, Ron Padgett & George Schneeman, John Yau & Archie Rand, Kathleen Fraser & Nancy Spero and with Charlie Morrow.

Index

When will the book be done? was designed by Taller de Comunicación Gráfica during the summer of 2000. This book was set in Frutiger and 2000 copies were printed in Hong Kong via Global Interprint of Santa Rosa, CA.

NYS not yet set
OP out of print
Prices in US$

David Antin and Charles Bernstein
A Conversation with David Antin — NYS

Susan Bee
Talespin — OP

Charles Bernstein & Susan Bee
Little Orphan Anagram — 1500.00

Charles Bernstein & Susan Bee
Log Rhythms — 35.00

Aaron Fischer
Ted Berrigan: An Annotated Checklist
hardback — OP
paperback — 32.95

Ted Berrigan & George Schneeman
In the Nam What Can Happen? — 500.00

bill bissett
Lunaria — NYS

William Blake
The Marriage of Heaven and Hell — 3000.00

Constance Lewallen
Joe Brainard: A Retrospective — 29.95

Jane Brakhage
From the Book of Legends — OP

John Cage et al
Nods — OP

Ken Campbell
Execution: The Book — 50.00

Paul Celan & Barbara Fahrner
Four Poems — 1500.00

Steven Clay & Rodney Phillips
A Secret Location
hardback — 44.95
paperback — 27.95

Clark Coolidge & Keith Waldrop
Bomb — 12.00
1/26 — 75.00

William Corbett et al
The Blind See Only This World — 12.00

Robert Creeley & Archie Rand
Drawn & Quartered — 15.95

Robert Creeley & Elsa Dorfman
En Famille — 19.95

Robert Creeley & Alex Katz
Ligeia: A Libretto — 400.00

Simon Cutts
A Smell of Printing — 15.00

Tennessee Rice Dixon
Scrutiny in the Great Round — OP

Toni Dove
Mesmer: Secrets of the Human Frame — OP

Henrik Drescher
Too Much Bliss — 5000.00

Johanna Drucker
Johanna Drucker Books: 1970 to 1994 — OP

Johanna Drucker
The Century of Artists' Books
hardback — 35.00
paperback — 24.95

Johanna Drucker
Figuring the Word — 24.95

Johanna Drucker
The History of the/my Wor(l)d — 50.00

Johanna Drucker
Luminous Volumes — OP

Johanna Drucker
The Word Made Flesh — 100.00

Joe Elliot & Julie Harrison
If It Rained Here — 1500.00

Kenward Elmslie
Nite Soil — 27.50
1/26 — 250.00

Kenward Elmslie & Trevor Winkfield
Cyberspace — 19.95
1/26 — 75.00

Timothy C. Ely
Memo 7 & Other Works — OP

Timothy C. Ely & Terence McKenna
Synesthesia — 1500.00

Ed Epping
Abstract Refuse — OP

Ed Epping
Secreted Contract — 175.00

Larry Fagin & Trevor Winkfield
Dig & Delve — 1500.00

Barbara Fahrner
Untitled broadsides — 300.00

Barbara Fahrner
Books and Drawings — OP

Ed Friedman & Robert Kushner
Away — NYS

Emily Erb Hartzel
At the Intersection of Cinema and Books — OP

Emily Erb Hartzel
Woman on Earth — OP

Walter Hamady
Boxes and Collages — 50.00

Granary Books
When will the book be done? — 40.00

Kenneth Goldsmith
Soliloquy — NYS

Ric Haynes
Rejected from Mars — 3000.00

Lyn Hejinian
A Border Comedy — NYS

Lyn Hejinian
The Lake — 19.95

Lyn Hejinian & Emilie Clark
The Traveler and the Hill and the Hill — 3000.00

Susan Howe & Susan Bee
Bed Hangings — 14.95

Renée Riese & Judd D. Hubert
The Cutting Edge of Reading — 55.00

Edmond Jabès & Ed Epping
Desire for a Beginning — 15.00
1/42 — NYS

Franz Kamin & Felix Furtwängler
The Man Who Was Always Standing There
bound — 2500.00
flats — OP

Shelagh Keeley
Notes on the Body — OP

Shelagh Keeley
A Space for Breathing — 3000.00

Basil King
Paintings from the Cards — OP

Stefan Klima
Artists Books: A Critical Survey — 17.95

Alison Knowles
Footnotes — 45.00
1/26 — 1000.00

Katherine Kuehn et al
Library: Book Artists' Invitational — 10.00

Ligorano/Reese
The Corona Palimpsest — 1800.00

John Locke
Books seem to me to be — 40.00

Kimberly Lyons
Abracadabra — 12.00

Kimberly Lyons & Ed Epping
Mettle — 200.00

Thomas McGrath
Mediterranean — 40.00

Emily McVarish
Was Here — NYS

Bernadette Mayer
Two Haloed Mourners — 12.00
1/17 — OP

Paul Metcalf
Firebird
in boards — OP
in wrappers — 100.00

Wendy Miller
everyday colors — OP

Simon Pettet & Duncan Hannah
Abundant Treasures — NYS

David Platzker & Steven Clay
[Printed Matter] — NYS

David Rathman
Roar Shocks
bound — 1500.00
flats — OP

Harry Reese
Funagainstawake — OP

Jerome Rothenberg & Steven Clay
A Book of the Book
hardback — 44.95
paperback — 28.95

Jerome Rothenberg & David Guss
The Book, Spiritual Instrument — 21.95

Jerome Rothenberg & David Rathman
Pictures of the Crucifixion — 375.00

Holton Rower
Non — 5000.00

Aram Saroyan
The Beatles — OP

Leslie Scalapino & Marina Adams
The Tango — NYS

George Schneeman & Anne Waldman
Homage to Allen G
in folder — 250.00
in box — 500.00

Carolee Schneemann
Vulva's Morphia — 1500.00

Kurt Schwitters & Barbara Fahrner
A Flower Like A Raven — 1500.00

Pati Scobey
The Back of Time — OP

Jane Sherry
Venus Unbound — 2500.00

J. Hoberman
On Jack Smith's Flaming Creatures — NYS

Something Else Press — OP

Buzz Spector
A Passage — OP

Jack Spicer & Fran Herndon
Golem — 150.00

Anne Waldman & Susan Rothenberg
Kin — 600.00

Anne Waldman & Lewis Warsh
Angel Hair Sleeps — NYS

Lewis Warsh
Bustin's Island '68 — 250.00

Jonathan Williams
Aposiopeses: Odds and Ends — OP

Jonathan Williams
Noah Webster to Wee Lorine — 20.00

Jane Wodening
What the Ambulance Driver Said — 75.00

Paul Zelevansky
The Case for the Burial of Ancestors — OP

John Zorn
Arcana — 24.95

(Tony Zwicker)
First Assembling for Tony Zwicker — 500.00